Decorative Painting
for the Garden

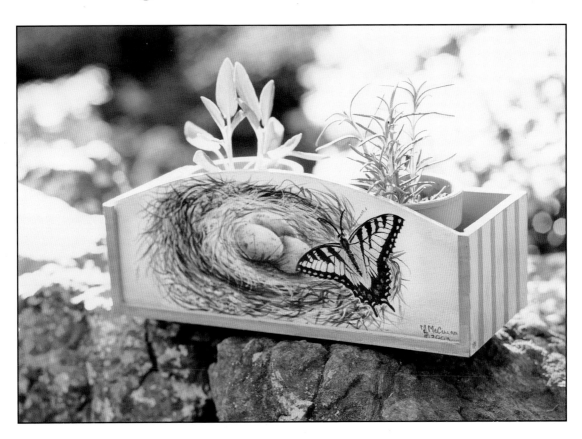

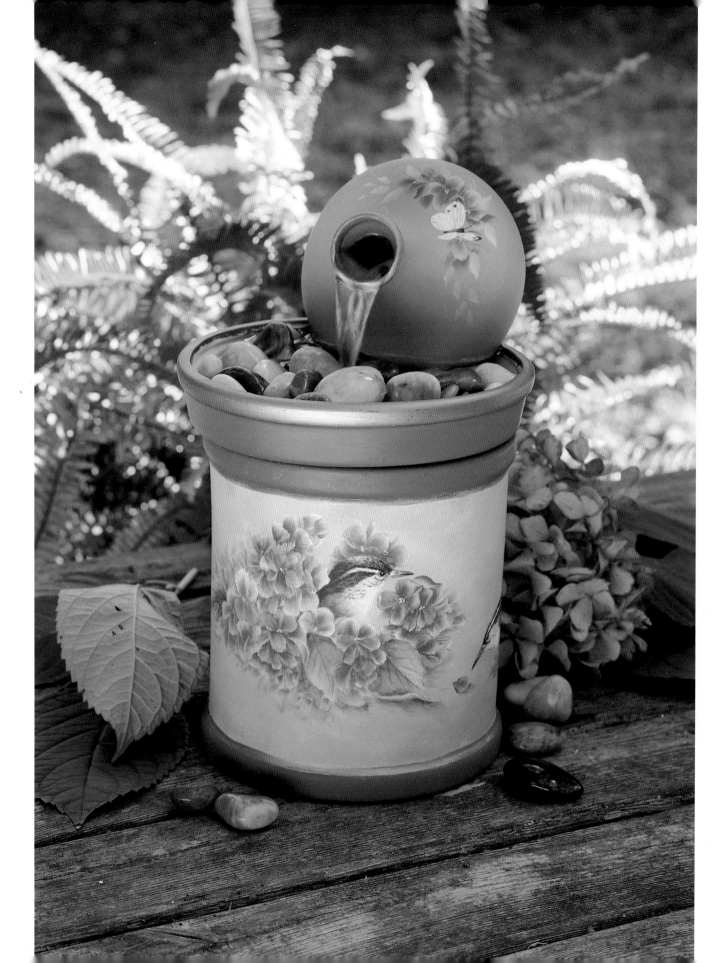

Decorative Painting
for the Garden

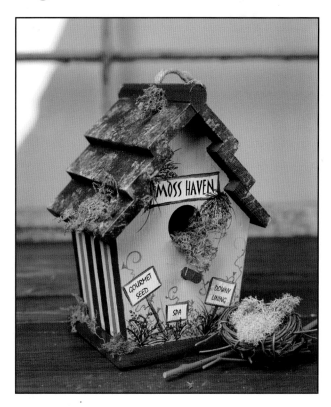

Sterling Publishing Co., Inc. New York

A Sterling / Chapelle Book

Chapelle, Ltd.

- Jo Packham • Sara Toliver • Cindy Stoeckl
- Editor: Laura Best
- Copy Editor: Marilyn Goff
- Staff: Kelly Ashkettle, Anne Bruns,
 Areta Bingham, Donna Chambers,
 Emily Frandsen, Karla Haberstich,
 Lana Hall, Susan Jorgenson,
 Jennifer Luman, Melissa Maynard,
 Barbara Milburn, Lecia Monsen,
 Suzy Skadburg, Kim Taylor,
 Linda Venditti, Desirée Wybrow

If you have any questions or comments,
please contact:
Chapelle, Ltd., Inc., P.O. Box 9252, Ogden, UT 84409
(801) 621-2777 • (801) 621-2788 Fax
chapelle@chapelleltd.com •www.chapelleltd.com

Plaid Enterprises

- FolkArt Product Manager: Dede Huey
- Admin. Book Division: Deena Haney
- Editorial Director: Mickey Baskett
- Styling: Kirsten Jones
- Illustrations/Graphics: Dianne Miller
- Copy Editors: Sylvia Carroll, Phyllis Mueller
- Photography: Jerry Mucklow

Library of Congress Cataloging-in-Publication Data

Decorative painting for the garden / Plaid.
 p. cm.
 Includes index.
 ISBN 1-4027-0728-2
 1. Painting. 2. Decoration and ornament. 3. Garden ornaments and
furniture. I. Plaid Enterprises.
TT385.D439 2004
745.7'23--dc22 2004308962

10 9 8 7 6 5 4 3 2 1

Published by Sterling Publishing Co., Inc.
387 Park Avenue South, New York, NY 10016
©2004 by Plaid Enterprises
Distributed in Canada by Sterling Publishing
c/o Canadian Manda Group, 165 Dufferin Street,
Toronto, Ontario, Canada M6K 3H6
Distributed in Great Britain by Chrysalis Books Group PLC,
The Chrysalis Building, Bramley Road, London W10 6SP, England
Distributed in Australia by Capricorn Link (Australia) Pty. Ltd.
P.O. Box 704, Windsor, NSW 2756, Australia
Printed and Bound in China
All Rights Reserved

Sterling ISBN 1-4027-0728-2

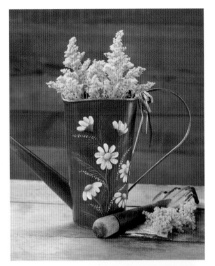

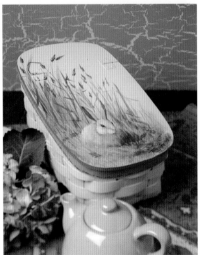

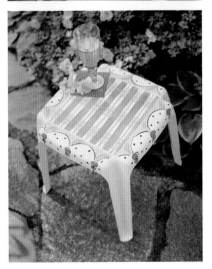

Table of Contents

General Supplies

Paints

Acrylic Craft Paints:

Acrylic craft paints are richly pigmented flat finish paints. They are packaged in bottles and available in a huge array of colors. They are ready to use with no mixing required. Simply squeeze paints from bottle onto palette and begin painting. Because they are water-based, acrylic paints dry quickly and clean up is easy.

While there are many subtle premixed shades, there are also pure, intense, universal pigment colors that are true to the nature of standard pigments. These colors can be inter-mixed to achieve additional true colors.

Acrylic craft paints also include metallic colors that add luxurious luster and iridescence to surfaces and can be used with any other acrylic paint.

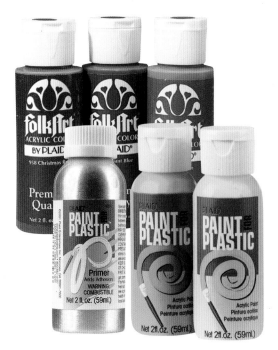

Indoor/Outdoor Acrylic Craft Paints:

These easy-to-use acrylic paints are durable, high-gloss enamels. This is the one paint for glass, ceramics, and indoor/outdoor use. These paints are weather resistant, which makes them the best choice for projects that will be used outdoors.

Paint For Plastic™:

Plaid's new Paint For Plastic is formulated to stay on and look great on flexible plastics (ABS, styrene, acrylic). Once dry, this acrylic paint is permanent. Its smooth opaque finish is perfect for decorative uses, and it comes in 39 colors including traditional, bright, metallics, and neons. It is easy to use and dries quickly. It is water-resistant, making it great for outdoor as well as indoor projects. And it will not chip off like conventional acrylics when used on hard plastic surfaces. Paint For Plastic can be used with brushes and with other painting tools such as sponges and stencils.

Paint For Plastic Primer:

When using Paint For Plastic on flexible plastic surfaces, you must first undercoat the painting areas with Paint For Plastic Primer. This is for those plastic items that would not crack or break if dropped. When undercoated with primer, the colors will adhere without chipping or scratching. This primer can enhance adhesion onto flexible surfaces, significantly broadening the number of plastic items you can decorate.

Painting Mediums

Blending Gel Medium:
This makes blending paint colors easier. It keeps the paints moist, giving more time to enhance your artistic expression with smoothly blended shading and highlights. Dampen painting surface with blending gel.

Extender:
When mixing with paint, an extender prolongs drying time and adds transparency for floating, blending, and washing colors. Create effects from transparent to opaque without reducing color intensity.

Floating Medium:
Floating medium is used instead of water for floating, shading, and highlighting. Load brush with floating medium, blot on paper towel, then load with paint.

Glazing Medium:
Glazing medium is added to acrylic craft paints to make the paint color slightly transparent and make the drying time a little longer, allowing more time for combing.

Thickener:
A thickener should be mixed with paint to create transparent colors while maintaining a thick flow and consistency. It is also used for marbleizing and other painted faux finishes.

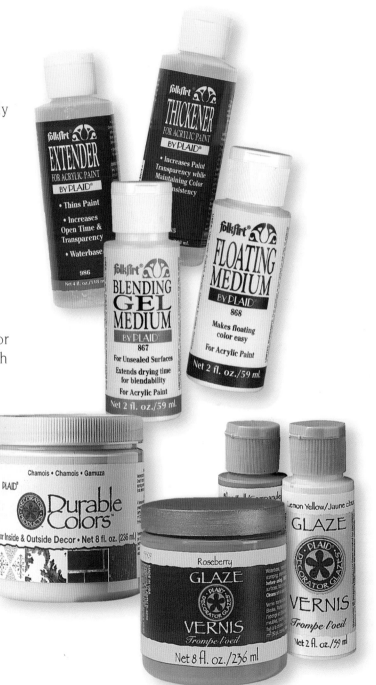

Brushes

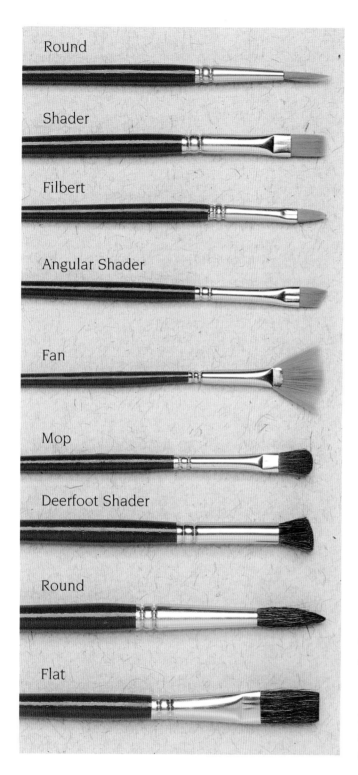

Round

Shader

Filbert

Angular Shader

Fan

Mop

Deerfoot Shader

Round

Flat

The brushes you use are important tools in achieving a successful painted design, so shop for the best you can afford. The size of the brush you will use at any given time depends on the size of the area or design you are painting. Small designs require small brushes, and so forth. Trying to paint without the proper size brush is a major mistake.

Flat, round, and liner brushes are the most important brushes to purchase. You could do all your decorative painting with these three brushes alone. However, as you get more proficient, you find yourself requiring more refined tools. Get the tool that will do a very specific job for the best results.

Miscellaneous Brushes

Angular Shader: This flat brush has bristles cut at an angle. It paints fine-chiseled edges and curved strokes, and blends.

Deerfoot Shader: This round brush has bristles which are cut at an angle. It is used for shading, stippling, and adding texture.

Fan: This finishing brush is used clean and dry. Lightly pounce flat side of brush on wet surfaces for textured effects. It also blends edges between wet glazes to achieve soft gradations of color.

Filbert: This flat brush has a rounded tip that makes fine-chiseled lines without leaving noticeable start and stop marks. It also makes curved strokes, fills in, and blends.

Mop: This round brush has soft long bristles. It is primarily used for smoothing, softening, and blending edges.

Scroller: This long-bristled round brush is used to make fine lines and scrolls. It is common to use thinned paint with this brush so that it flows easily onto the project surface.

Stencil: This round brush has either soft or stiff bristles. Use with either a pouncing motion or a circular motion.

Rectangular Brushes

Flat: This flat rectangular brush has long bristles. The chisel edge makes fine lines and the flat edge makes wide strokes. It carries a large quantity of paint without having to reload often. It is used for double-loading, side-loading, and washing.

Scruffy: This wide rectangular brush has short bristles. It cannot be used for strokes but works well for pouncing or stippling, dry-brushing, or dabbing.

Wash: This large flat brush is used to apply washes of color and finishes.

Round Brushes

Liner: This round short-bristled brush is used to paint small areas. It is often used to paint fine, flowing lines and calligraphic strokes.

Round: This round brush has bristles that taper to a fine point. It is used in base-painting and stroke work. The fine tip works well for painting details and tiny spaces.

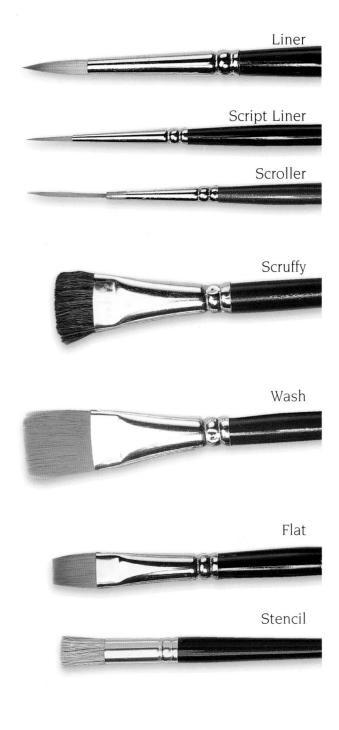

Liner

Script Liner

Scroller

Scruffy

Wash

Flat

Stencil

Brush Care & Cleanup

Brushes must be properly cleaned and cared for. A good quality brush has sizing in it to hold the bristles in place. Before painting, remove sizing by gently rolling bristles between fingers and thoroughly cleaning brush with water. After completing painting, wash the brush. Never let paint dry in your brush. Hold the brush under running water and rinse paint until the brush is clean. Then work some dishwashing liquid or brush cleanser back into the bristles and shape the end (either to a point or a square edge, depending on brush type.) Do not rinse.

When cleaning liner brushes, be careful not to abrade or abuse bristles. Work bristles back and forth with a brush cleanser. After removing paint from brush, leave cleanser in bristles and twist and roll bristles between your fingers to reshape. Before painting again, rinse soap out of bristles.

Miscellaneous Supplies

Brush Cleanser: Use a liquid brush cleanser that can clean wet or dried paint from bristles and keep brushes groomed between uses.

Combing Tool: Similar to a hair comb, this tool is pulled through wet paint, leaving a lined pattern.

Dome Brush: This sponge brush has a flat, rounded end used when scrubbing and stenciling.

Palette: Place small amounts of each paint to be used on a palette. Load brush, blend paint into brush, and mix colors on a palette.

Palette Knives: Knives come in two styles and are used for mixing and applying paint. Both styles have long flat blades, but one has an elevated handle to help keep your hand out of the paint. A good palette knife should be thin and flexible when it touches the project surface.

Sandpaper: Use 120-grit sandpaper to sand a wood project surface before base-painting. Use wet/dry 220-grit sandpaper to sand dry base coats between applications.

Soft Cloth: Use a cloth to wipe off excess mediums and to clean brushes.

Sponge Brush: Use a sponge brush to apply a base coat on a project surface before decorative painting. Sponge brushes are also used to apply finishing coats.

Sponge Roller: Use a sponge, or stencil, roller to apply base coats to large areas.

Steel Wool: Use a very fine-grade steel wool to sand project between sealer coats to help sealer coats to adhere.

Stylus: A stylus is a pencil-like tool used to transfer a traced design onto a prepared surface. A pencil or a ballpoint pen that not longer writes may also be used.

Tack Cloth: Use a tack cloth to remove residual dust after every sanding.

Tracing Paper: Trace a design or pattern onto tracing paper. Choose a tracing paper that is as transparent as possible for accurately tracing designs or patterns.

Transfer Paper: Transfer traced design or pattern to project surface, using transfer paper. Choose transfer paper that has a water-soluble coating in a color that is visible on the base-paint color of project.

Water Container: A water container with a ridged bottom helps rinse and clean brush bristles. Do not allow ferrule and handle to remain in water.

Wood Filler: Wood filler is applied with a putty knife to fill holes. After putty is thoroughly dry, sand project to a smooth finish.

Finishing Supplies

Choose sealers that are nonyellowing and quick drying. Brush-on sealers are economical, but aerosol sealers are convenient and available in gloss or matte finishes. If project is too shiny after finish coats are dry, buff with a fine-grade steel wool or water-moistened 400-grit sandpaper.

On painted surfaces, spray the dry completed project with sealer. Let dry. Spray a second coat. Let dry. Sand surface with wet 400-grit sandpaper, or with a fine-grade steel wool. Tack away dust. If necessary, apply a third coat or more.

If the project is made of new wood and has been stained or glazed, the wood is rather porous, requiring more coats than a painted surface. A piece that will be used outdoors will need more finish coats for protection from the weather.

Finishes

Acrylic Sealer:

This sealer gives a durable finish that protects painting without changing appearance. It brushes on and dry with no yellowing.

Decoupage Finish:

This type of finish is designed to use for both gluing and coating. It contains solids and dryers to achieve a thick buildup that dries quickly.

This finish is also self-leveling so it will dry smoothly.

Polyurethane Outdoor Varnish:

This varnish protects projects with a durable finish that will stand up to the elements of the outdoors. It brushes on and dries clear with no yellowing. It is available in a matte, gloss, or satin finish.

Spray Sealer:

Aerosol finishes are sprayed onto painted surfaces to seal and protect against moisture, soil, and dust. They dry clear and are non-yellowing. They can be found in both a gloss and a matte finish.

Water-based Varnish:

Giving maximum durability for outdoor projects, this brush-on liquid finish protects and seals surfaces and dries with a satin finish. It also offers excellent resistance to scratches and water spotting.

General Instructions

Preparing Surfaces

Make certain to prepare project surface with primer or base paint before applying patterns and decorative painting. Primer paints are specially formulated to adhere onto wood or plastic. Projects painted without primer can peel, crack, or powder off sooner than those prepared with primer.

When sanding between coats of primer, paint, or sealer, check surface for smoothness. If surface appears scratched after sanding, you are either using sandpaper or steel wool that is too coarse or you are sanding surface before paint, primer, or sealer is completely dry. If this happens, use a finer-grit sandpaper or let the surface dry, then sand again. Using a tack cloth, tack away dust after sanding.

To "sand" with a paper bag, cut a heavy brown paper bag into 6" squares. When the base paint has dried, rub the surface with the paper bag pieces. The paper polishes the surface and makes the design painting easier. If a second base coat is applied, repeat the paper bag sanding when the second base coat has dried.

Be careful not to use paper bag pieces with printing on them. Most printing inks will rub off onto the painted surface.

Preparing Metal

Tin is featured in items such as watering cans, buckets, and garden tools. Wrought iron also has become more popular with greater interest in yard and garden decor. Metal items for outdoor accessories can be found at department stores, craft shops, hardware stores, and garden centers.

Preparing New Tin:

New tin needs no preparation. Galvanized tin has an oily film that must be removed before painting. Clean item with water and vinegar, using a sponge or soft cloth. Do not immerse piece in water. Rinse well and dry thoroughly. Painted or enameled tin requires damp sponging with water and drying.

Preparing Rusted Tin:

Test rusted pieces for residue by gently rubbing your finger over the surface. Some rusted tin has been treated, preventing rusty residue from processing. This will make painting less messy. Before base-painting, spray rusted tin with a light coat of acrylic sealer to help prevent rust from bleeding through paint.

Preparing Old Metal:

Sand surfaces or rub with steel wool to remove loose paint or rust and to smooth imperfections. Wipe with a cloth dampened in turpentine and let dry. Brush or spray with metal primer. Let primer dry completely, then sand lightly with fine-grit sandpaper. Wipe with a tack cloth to remove sanding particles. Base-paint with two coats of acrylic paint. Let paint dry between coats.

Sometimes you may wish to keep previously painted surface on an old piece. If the existing paint has a high-gloss finish, use a very fine emery cloth to take down the gloss in the area of your design so paint can grab the surface.

Preparing Plastic

Plastic is often a substitute for glass because it is lightweight, break-resistant, and inexpen--sive. Painting on plastic is so easy that the only preparation needed is to clean the item. Use rubbing alcohol to clean the plastic surface, removing static charge and dirt for better adhesion and smoother application. Be certain the item has dried thoroughly before painting.

Most acrylic paints will not stick to plastic. They may bead-up while painting or, after drying, may peel off. This can be avoided by either misting the plastic pieces with a spray acrylic sealer, or by using paints and primers that are specifically formulated to use with plastic. If surface is shiny, apply two coats of plastic primer.

Preparing Terra-cotta

There is a wide range of items made of terra-cotta, especially in garden ornaments, planters, and flowerpots. Flowerpots and planters also can be used to make other items such as bird-baths and fountains.

There is little preparation to terra-cotta projects. Wash and dry, if necessary, with mild soap and water. If dirt is stubborn, use a water and vinegar solution—one cup vinegar to one quart water. If planting directly in the painted pot, seal the inside so water and moisture will not soak through to the painted surface. Coat inside with water-based outdoor sealer.

If you are base-painting, paint with only enough water to allow paint to move easily over the surface—a heavier application than you would use on wood. If you have too much water, it bleeds out. A heavier base coat also helps keep the color truer and brighter.

Preparing Wood

The variety of paintable wooden pieces is exceptionally wide. There are small pieces such as house number signs or birdhouses. Wooden containers abound—boxes, baskets, and out-door furniture. Some containers that are made of other materials, like glass or ceramic canisters, may have wooden lids. There are also wooden items for strictly decorative purposes, which are usually made of another material, such as wooden watering cans or flowerpots.

Larger wooden pieces are generally furniture items. Furniture can be found in unfinished wooden furniture or discount stores that include some unfinished furniture pieces in their stock.

Filling Holes:

Be certain surface is clean and free from dirt and oil. Fill nail holes, cracks, or gaps with a neutral color of stainable latex filler. Using a small palette knife, apply as little as necessary to fill area. Remove excess while wet. Let dry, then sand smooth. If area appears sunken after drying, repeat with second application.

Sanding:

To smooth rough areas, sand wood projects with the grain of the wood. Start with a coarser grit sandpaper and finish with a finer grit.

Preparing Unfinished Wood:

Be certain surface is clean and free from dirt and oil. Sand new wood to smooth rough areas. Use 120-grit sandpaper until surface appears dusty and smooth, then use 220-grit sandpaper to finish. Sand with the grain. To round sharp edges, use a coarse-grit sandpaper, then finish with fine-grit sandpaper.

Using a tack cloth, wipe away dust after sanding. Blow dust from crevices and corners.

Some wooden projects can be primed or base-painted with antiquing stain instead of paint. Apply antiquing stain the same way you would paint.

Each piece of wood is different and will react differently to paint. You will find times when the wood will not take paint well, and you may end up with a splotchy effect. If so, sand the surface again. Wipe away dust with a tack cloth.

Seal with primer. To obtain thinned sealer, simply dilute with water.

Transferring Patterns

Place tracing paper over pattern in book and secure with low-tack masking tape. Using a marking pen or pencil, trace major design elements onto tracing paper. If necessary, enlarge traced pattern on a photocopier to specified percentage. Use detailed pattern and photographs as visual guides when painting.

Position traced pattern onto project. Secure by taping one side with masking tape. Slip the appropriate color of transfer paper, velvet side down, between tracing and project surface. Using a stylus, retrace pattern lines, with enough pressure to transfer lines but not so much that you indent the surface.

Clear plastic is transparent, so you can tape your pattern inside rather than transferring it. If that is difficult due to shape or color, you may transfer it in the usual manner with transfer paper.

Painting the Design

Read through instructions before beginning a project. Paint project steps in the order specified. Keep instructions and project photographs handy while working.

Try a few practice strokes before painting the design. Practice directly on top of worksheets photocopied from this book. Place tracing paper or plastic over the worksheet and practice painting the strokes on the overlay.

Acrylic Painting Tips:

- Squeeze paint onto palette, making a puddle of paint about the size of a nickel.

- Pull color with brush from edge of puddle. Avoid dipping brush in center of puddle, putting too much paint on brush edges.

- Let each coat dry before applying another. If area is cool to the touch, it is probably still wet.

- Acrylic paints blend easily. Add white to lighten a color; add black to darken a color.

Using a Painting Worksheet

Painting worksheets have been included with many of the projects in this book. The paint colors used on the worksheets are the same as those used in the finished projects. The different items in each project are grouped together on the worksheet. You may choose to complete an entire item before moving to the next or you may choose to do all the base painting, then all the shading, and so forth. Since the elements are grouped, follow the succession in numerical order when given as shown in the illustrated Worksheets A and B examples below and at the right. Arrows are added to some worksheets representing the way the stroke should be done.

Painting worksheets demonstrate a variety of painting techniques and allow you to practice a stroke before attempting it on your project surface.

Some worksheets are available with a protective plastic coating so you can paint directly on it, then wipe it clean when finished. The worksheets in this book can be used similarly. Color-copy the worksheet, then cover it with clear plastic wrap, or a sheet of acetate.

Worksheet B

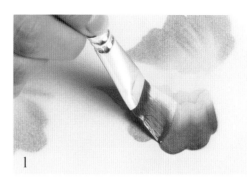

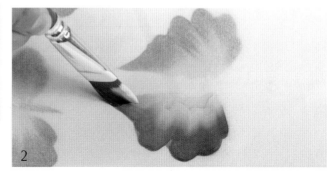

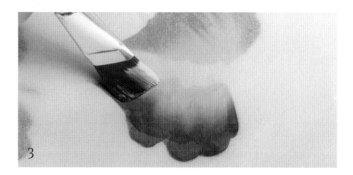

Worksheet A

Flower:

1. Paint a stroke for each petal.

2. Add center lines.

3. Add center details.

Finishing

Most projects are finished with a water-based outdoor sealer. Apply finish with a sponge brush after paint is completely dry. Use the largest size sponge brush that can be reasonably used on the project. A large brush requires fewer strokes to cover the project, which means it is easier to apply a smooth finish.

Spray finishes work well with smaller projects and provide an extra-smooth finish. As a rule, a spray finish dries faster than a brush-on finish, and a single coat is not as thick.

In most cases, no finish is needed on plastic projects. If the item will receive excessive wear, or be used where it is subjected to varying weather conditions, apply a coat of sealer made for use with paints for plastic. Wait 48 hours per coat after painting to allow paint to completely cure before applying sealer. Brush on sealer with smooth brush strokes. Apply a second coat, brushing in the opposite direction.

Finishing Tips:

- After paint is dry, erase any visible pattern lines before sealing.

- On painted surfaces, spray the dry completed project with a coat of sealer. Let dry. Spray a second coat and let dry. Sand surface with wet 400-grit sandpaper or with a very fine-grade steel wool. Tack away all dust. If necessary, apply a third finish coat.

- If project is made of new wood and was stained or glazed, the wood may be porous requiring more coats than a painted surface.

- A piece that will receive a lot of use will need more finish coats for protection. If your project is a surface such as a tabletop that will receive heavy use, apply polyurethane. Both matte and gloss finishes are appropriate.

- Applying only one or two coats of finish on a distressed surface will keep the project looking weathered, worn, and aged.

- If project is too shiny after finish coats are dry, buff with a very fine-grade steel wool or water-moistened 400-grit sandpaper.

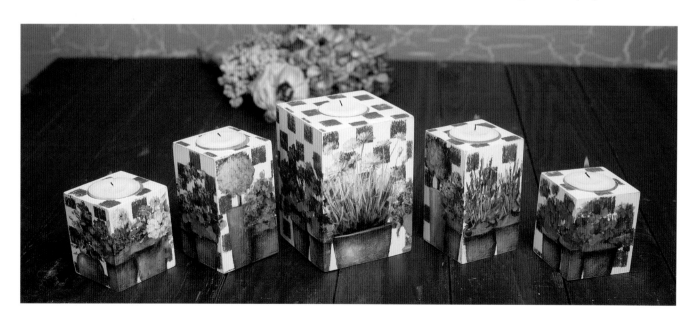

Basic Painting Terms

Base-paint: to cover an area with one or several initial coats of paint. Let dry before continuing.

Comb: to add texture and pattern to surfaces.

Dirty Brush: contains wet color left from last application. Wipe brush gently, pick up next color, and begin painting.

Distress: gives the effect of a paint finish that has naturally worn with time. Two different colors of paint are used.

Double-load: to load two paint colors on brush to make a third color at center of brush.

Dry-brush: refers to brushing on a color with an almost dry brush to create shading or highlighting.

Dry-wipe: by wiping paint off brush onto paper towel until brush is nearly dry.

Float: to shade or highlight a color. Load brush with floating medium, then load one corner of brush with a paint color.

Highlight: to lighten and brighten. Apply a few layers of paint rather than one heavy layer. Highlight on a moist surface for a soft effect, or on a dry surface for a brighter look.

Inky: to dilute paint with water until paint is the consistency of ink.

Load: to fill brush with paint color. Stroke brush back and forth in paint until saturated.

Pat-blend: to combine different paint colors. Using blending gel tap brush lightly on project to gently combine paint colors.

Shade: to deepen color within design and create dimension. Apply paint color with a side-loaded brush on a slightly moistened surface. *Note: Shading can be applied as many times as needed to build depth and intensity of color. Let paint dry before adding another layer of color.*

Side-load: for shading or highlighting. Moisten a flat or filbert brush with extender or water. Dip brush corner in paint then stroke lightly several times on palette to distribute paint.

Spatter: to speckle a project. Using an old toothbrush, dip bristles into water. Blot on paper towel to remove excess water. Dip bristles into paint, working in paint by tapping on palette. Aim at project and pull fingernail across bristles to release paint specks.

Sponges: consisting of cellulose or natural ocean sponges depending on the desired coverage on the project surface.

Stipple: to blend or paint colors with a brush-tip pattern. Pounce tips of brush bristles on project surface. Wipe brush with a rag to clean. DO NOT wash brush until finished for the day. You cannot stipple with a damp brush.

Thin: to dilute with water, or with extender or glazing medium as instructions require.

Tint: to add touches of color for interest and depth. Load a small amount of contrasting paint on a filbert brush and apply to project. To soften color, lightly brush with mop brush.

Wash: to alter or enhance a painted design. Apply a layer of thinned paint over a dry coat.

Wet-into-wet Blending: is using two or more colors and blending while still wet.

Loading a Flat Brush

1

2

1. Hold brush at edge of puddle of paint color on palette. Pull paint out from edge of puddle with brush, loading one side of brush.

2. Turn brush over and repeat to load other side. Keep flipping brush and brushing back and forth on palette to fully load bristles.

Loading a Liner

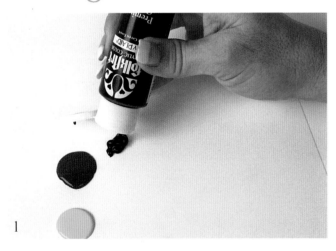

1

2

1. Squeeze puddle of paint color onto palette and dilute it at edge with water.

2. Stroke liner along edge of puddle, pulling paint into bristles. Stroke brush on palette to load paint into bristles.

Loading a Round Brush

1. Hold brush at edge of puddle of paint color on palette. Push brush straight down into puddle.

Loading a Scruffy Brush

1. Hold brush at edge of puddle of paint color on palette. Push brush straight down. Rotate brush. Be certain bristles are loaded.

Double-loading

1. Load flat brush with floating medium. Blot off excess on paper towel until bristles lose their shine. Touch one corner of brush in one paint color on palette. Touch opposite corner of brush in another paint color.

2. Stroke brush to blend colors at center of bristles. Colors should remain unblended on corners.

Multi-loading

1. Load flat brush with floating medium. Blot off excess on paper towel until bristles lose their shine. Touch one side of brush in one paint color on palette. Touch opposite side of brush in another paint color. Touch one tip of one side into third color.

2. Stroke brush to blend colors at center of bristles. Colors should remain unblended on corners.

Side-loading

1. Load flat brush with extender. Blot off excess on paper towel. Touch corner of brush in paint color on palette.

2. Lift brush and blend on palette. Color will drift softly across bristles, fading into nothing on opposite side.

Dry-brushing

1. Load flat, scruffy, or stencil brush with paint color on palette. Brush several times on paper towel to remove most of paint.

2. Apply paint in scrubbing motion to either shade or highlight image, adding just a touch of color.

Floating

1. Fully load flat brush with floating medium. Blot off excess on paper towel. Side-load brush with paint color by pulling brush edge along puddle on palette. Load only ⅓–½ of brush. Brush back and forth on palette to blend color into brush.

2. Pull brush along edges in design area. *Note: Color should be on the edge and fade as it reaches the center.*

Antiquing

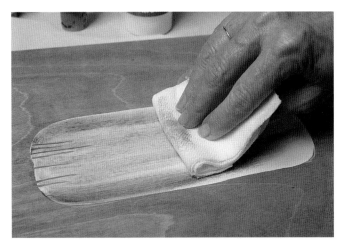

1. Brush antiquing medium over surface and wipe away excess with a soft cloth. Note: Antiquing glaze can be made by mixing one part acrylic paint color with three parts glazing medium. Apply as with antiquing medium.

Crackling

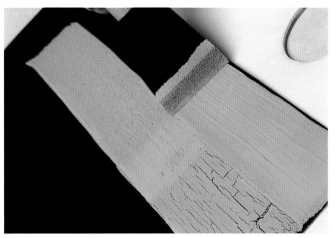

1. Base-paint project with acrylic paint. Let dry. Using sponge brush, apply generous coat of crackle medium. Let dry. Apply an acrylic topcoat. As it dries, the cracks will form. Note: A *thick topcoat produces large cracks*. A *thin topcoat produces smaller cracks*.

Patting

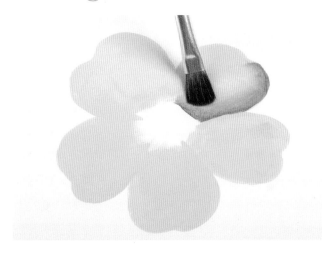

1. To highlight or shade apply a small amount of paint in a "patting" motion to add desired color. Be certain to only add to one side of the object to give the impression of highlights or shade.

Dotting

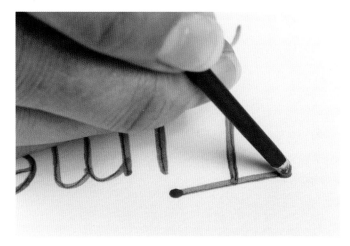

1. Dip end of brush handle or stylus into paint. Touch tip on surface to form a dot.

Distressing

1. Base-paint surface with desired paint color. Let dry.

2. Using candle wax or a wax stick, apply streaks of wax to areas of finish where you want worn-paint look.

3. Apply topcoat of paint in different color to completely cover first color. Let dry.

4. Sand through topcoat in the area where wax was applied to reveal some of bottom layer. *Note: The wax will allow the topcoat to be removed easier, looking like the topcoat has peeled away and become worn.*

Decoupaging

1. Using small sharp scissors, cut out paper motif. Brush decoupage finish in design area, then press paper motif onto it.

2. Coat top of entire design with decoupage finish to seal. Let dry.

Spattering

Sponging

1. Using stencil brush or old toothbrush, dip bristles into water. Blot on paper towel to remove excess water. Dip brush into paint color on palette. Work paint into bristles by tapping on palette. Point brush toward area to be spattered and pull finger or thumb across bristles to send "spatters" of paint onto project.

1. Dip a damp sponge into paint on a palette. Blot on a paper towel to remove excess. Press sponge on the base-painted project, then lift. Repeat, turning sponge a bit each time.

Stenciling

1. Using dry stencil brush, dip bristle tips into paint color on palette. Brush paint on paper towel to remove almost all paint.

2. Apply paint in cut-out areas of stencil. *Note: Sometimes you are instructed to use a circular motion and other times you are instructed to pounce the color in the area.* Gradually build up color to desired intensity. Use clean, dry stencil brush for each color. Do not rinse brushes until finished with stenciling, then clean brushes.

Stippling

1. Using stencil brush, pick up paint color on palette, then blot brush once or twice on paper towel. Pounce up and down on design area.

Taping

1. With a ruler, mark lines for the tape to run against. Apply tape. Paint untaped areas with second color (you do not have to worry about paint overlapping the tape), then remove tape before paint is dry.

Basic Brush Strokes Worksheet

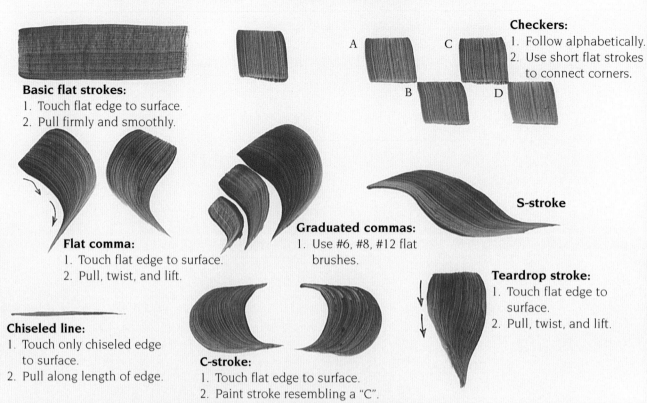

Flat brush

Checkers:
1. Follow alphabetically.
2. Use short flat strokes to connect corners.

A C B D

Basic flat strokes:
1. Touch flat edge to surface.
2. Pull firmly and smoothly.

S-stroke

Flat comma:
1. Touch flat edge to surface.
2. Pull, twist, and lift.

Graduated commas:
1. Use #6, #8, #12 flat brushes.

Teardrop stroke:
1. Touch flat edge to surface.
2. Pull, twist, and lift.

Chiseled line:
1. Touch only chiseled edge to surface.
2. Pull along length of edge.

C-stroke:
1. Touch flat edge to surface.
2. Paint stroke resembling a "C".

Round brush

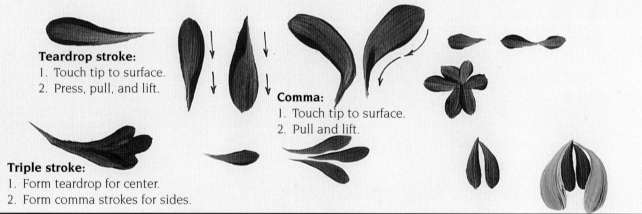

Teardrop stroke:
1. Touch tip to surface.
2. Press, pull, and lift.

Comma:
1. Touch tip to surface.
2. Pull and lift.

Triple stroke:
1. Form teardrop for center.
2. Form comma strokes for sides.

Liner

Squiggle & line:
1. Touch tip to surface.
2. Paint desired freehand squiggle or line.

Crosshatching:
1. Touch liner tip to surface.
2. Crisscross with thin lines.

Lettering:
1. Touch tip to surface.
2. Always pull brush toward you.

Projects

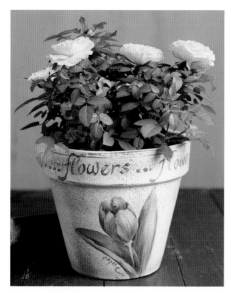

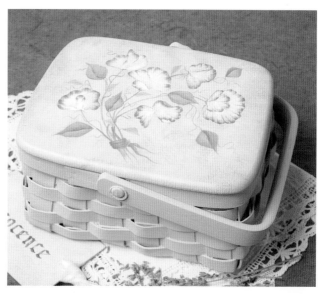

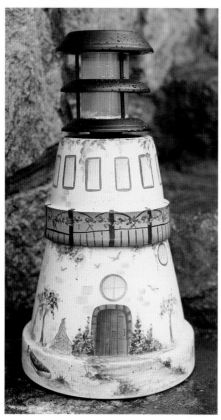

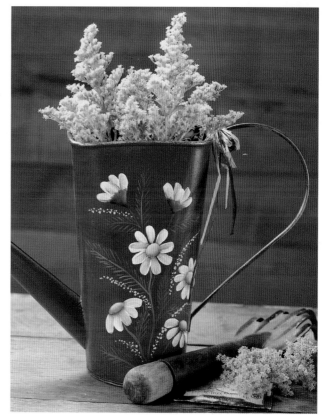

Bunny Basket

Designed by
Trudy Beard

Supplies

Project Surfaces:
Basket with wooden lid
 7" x 11"

Acrylic Colors:
Buttercrunch
Lavender
Light Periwinkle

Acrylic Pigment Colors:
Burnt Umber
Dioxazine Purple
Hauser Green Dark
Hauser Green Light
Raw Sienna
Warm White
Yellow Citron

Brushes:
Flats: #2, #6, #10, #12
Script liner: #00

Other Supplies:
Combing tool: #10 or #12
Glazing medium
Palette
Palette knife
Paper towels
Sandpaper
Tack cloth
Transfer paper
Transfer tools
Water-based outdoor sealer

Instructions

Prepare:

1. Refer to Preparing Surfaces on pages 12–15. Prepare wooden basket and lid.

2. Apply thinned sealer. Let dry.

Paint the Design:

1. Refer to Brushes to Use on pages 8–9. Use appropriate brush type and size for area to be painted.

2. Base-paint basket with Buttercrunch.

3. Paint top edge of basket with Lavender.

4. Using end of brush handle, add dots with Hauser Green Light. Let dry.

5. Refer to Transferring Patterns on page 15. Transfer Bunny Pattern on page 32 onto lid.

Lavender Grasses:

1. Refer to Bunny Painting Worksheet on page 33. Base-paint dark grasses with Hauser Green Dark plus glazing medium. Dry-wipe brushes.

2. Using combing tool, add texture to grass area.

3. Apply middle values with Yellow Citron plus blending gel.

4. Apply the lightest values and Yellow Citron plus Buttercrunch plus a little blending gel.

5. Using script liner, paint individual grass blades with the same mixtures thinned with a little water.

Bunny:

Note: *Work wet into wet. If you feel paint drying out, pick up blending gel plus paint to allow time to pat-blend values.*

1. Base-paint dark areas with Burnt Umber plus Raw Sienna.

2. Base-paint light areas with Raw Sienna plus Warm White.

3. Using flat, pat on lighter values. Mix Raw Sienna plus Warm White; blot, then apply.

4. Intensify highlights and strengthen shadows with Raw Sienna plus Warm White mixture.

5. Paint eyes with Burnt Umber. Highlight with Warm White.

6. Using script liner, add detail lines to define nose, eyes, and mouth with thinned Burnt Umber.

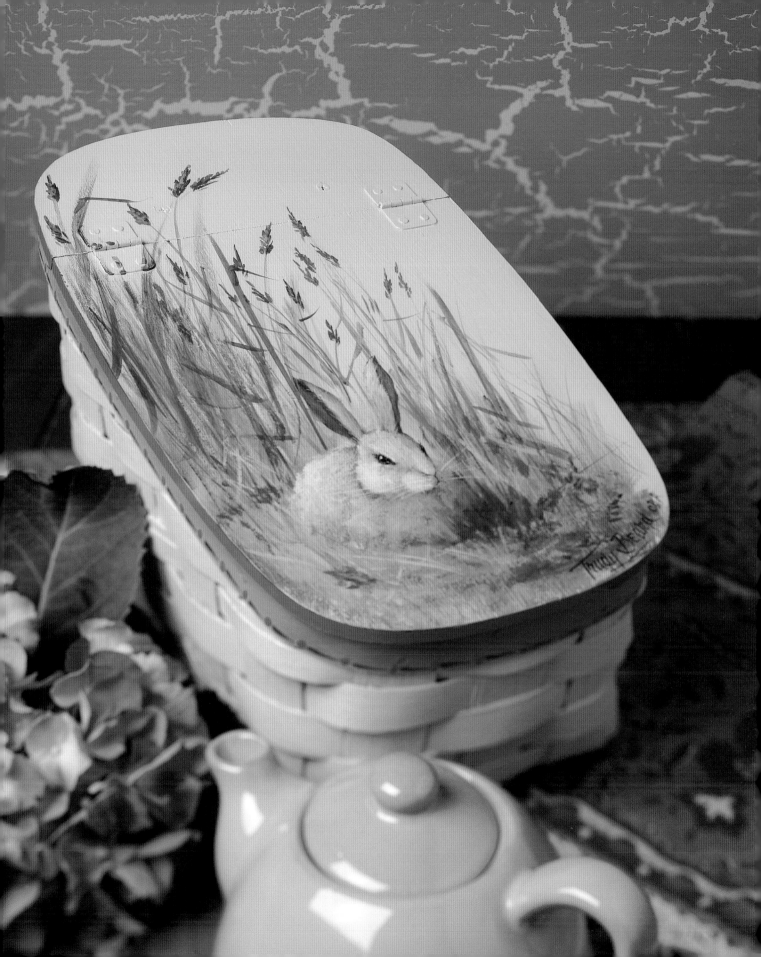

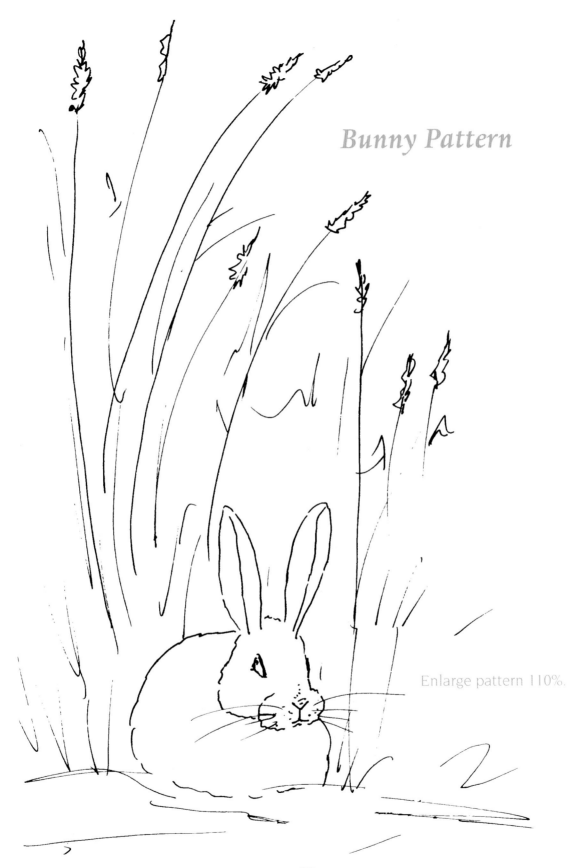

Bunny Pattern

Enlarge pattern 110%.

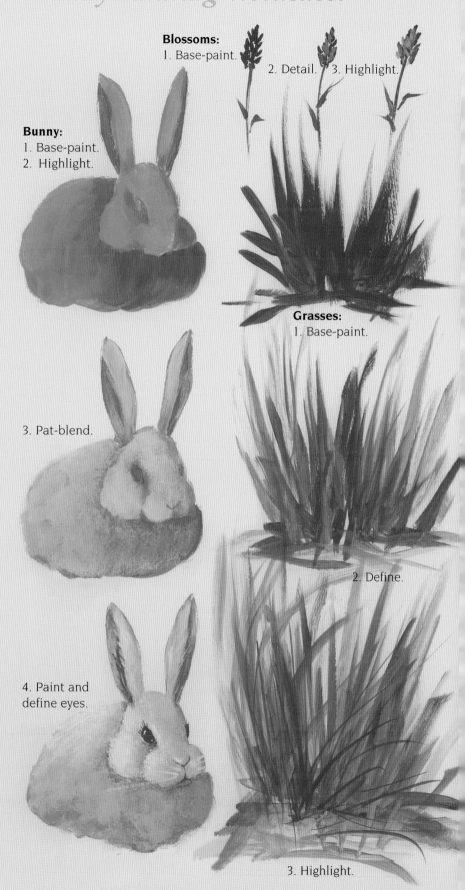

Lavender Blossoms:

1. Using chiseled edge of small flat, stroke in dark values with Dioxazine Purple plus Lavender. Dry-wipe brush.

2. Stroke in middle values with Lavender.

3. Stroke in light values with Light Periwinkle. Let dry.

Finish:

1. Following manufacturer's instructions, apply two or more coats of sealer. Let dry.

Blossoms:
1. Base-paint.
2. Detail. 3. Highlight.

Bunny:
1. Base-paint.
2. Highlight.

Grasses:
1. Base-paint.

3. Pat-blend.

2. Define.

4. Paint and define eyes.

3. Highlight.

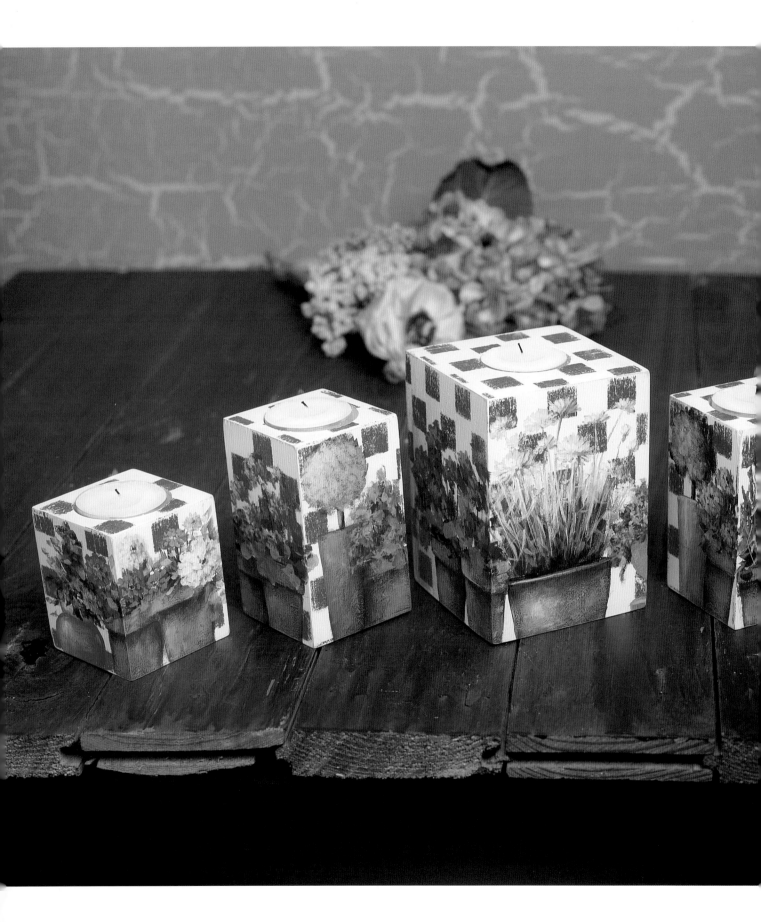

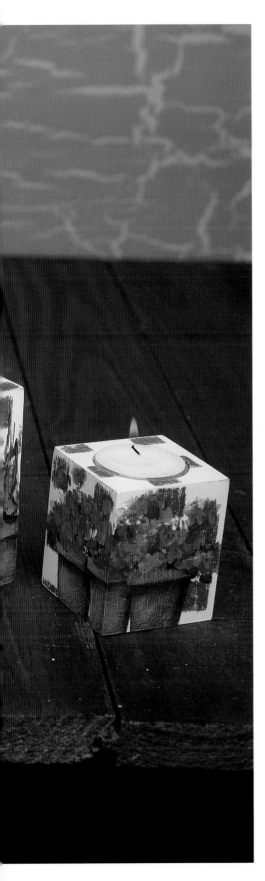

French Market Candle Blocks

Designed by
Trudy Beard

Supplies

Project Surfaces:
Wooden candleholder
 blocks (5)

Acrylic Color:
Gray Plum

Acrylic Pigment Colors:
Alizarin Crimson
Brilliant Ultramarine
Burnt Carmine
Burnt Sienna
Cobalt
Dioxazine Purple
Hauser Green Dark
Hauser Green Light
Napthol Crimson
Pure Black
Pure Orange
Raw Sienna
Turner's Yellow
Warm White
Yellow Citron
Yellow Light

Brushes:
Flats: #2, #4, #6, #8, #10
Script liner: #00
Stencil: ½"

Other Supplies:
Candles
Masking tape
Palette
Palette knife
Paper towels
Precut stencil, ½" checkerboard
Sand paper
Tack cloth
Transfer paper
Transfer tools
Water-based outdoor sealer

Instructions

Prepare:
1. *Refer to Preparing Surfaces on
pages 12–15.* Prepare blocks.

2. Apply thinned sealer.
Let dry.

3. Sand surface. Using tack
cloth, wipe away sanding dust.

Paint the Design:
1. *Refer to Brushes to Use on pages
8–9.* Use appropriate brush type
and size for area to be painted.

2. Base-paint candle blocks
with two or more coats of
Warm White. Let dry.

3. Position stencil and secure
with masking tape.

4. Using stencil brush, pounce
Cobalt over stencil into the
cut-out areas. Let dry.

5. Lightly sand sides and edges of blocks to create a vintage look.

6. *Refer to Transferring Patterns on page 15.* Transfer French Market Patterns on pages 37–38 onto blocks.

Blue Pot:

1. *Refer to French Market Painting Worksheet on page 37.* Base-paint pot with Cobalt plus a little Warm White.

2. Shade with Cobalt plus a bit of Pure Black. Clean brush in water and squeeze dry.

3. Mix Cobalt plus Warm White. Apply a light value on light side of pot. Dry-wipe brush and pick up more Warm White. Add final highlights.

Clay Pots:

Note: *Apply light values, highlights, and accent color, using a dry-brush technique—load brush with paint; blot on paper towel, and lightly drag brush over dry surface to create a textured look.*
1. Base-paint pots with Burnt Sienna.

2. Shade with Burnt Carmine plus Burnt Sienna. Clean brush in water and squeeze dry.

3. Mix Burnt Sienna plus a little Napthol Crimson and a little Warm White. Apply this light value where indicated on the worksheet. Dry-wipe brush.

4. Add final highlights with Burnt Sienna plus Warm White.

5. Add accent color on shadow side with Brilliant Ultramarine plus Warm White.

Tall Gray Pots:

1. Base-paint tall pots with Gray Plum plus a tiny bit of Burnt Carmine. Wipe brush.

2. Shade with a bit of Burnt Carmine. Clean brush.

3. Highlight with Gray Plum plus Warm White.

4. Add final highlights with Warm White.

5. Dry-brush accent color on shadow side with Brilliant Ultramarine plus Warm White.

Gray Urn:

1. Base-paint urn with Gray Plum.

2. Shade with Gray Plum plus Pure Black. Clean brush.

3. Highlight with Gray Plum plus Warm White.

4. Add accent color to shadow side with Brilliant Ultramarine plus Warm White.

Geraniums:

1. Using chiseled corner of small flat, base-paint geraniums with Alizarin Crimson plus Napthol Crimson.

2. Pick up a little Warm White and apply this lighter value in the same manner.

3. Using #4 flat, paint foliage with Hauser Green Dark.

4. Highlight with Hauser Green Light.

Marigolds:

1. Using chiseled edge of small flat, paint marigolds with Turner's Yellow.

2. Shade marigolds with Raw Sienna. Clean brush and squeeze dry.

3. Highlight marigold blossoms with Yellow Light.

4. Base-paint foliage with Hauser Green Dark plus a little Dioxazine Purple. Clean brush and squeeze dry.

5. Using chiseled edge of flat, highlight foliage with Hauser Green Light. Add a stronger highlight with Warm White plus Yellow Citron.

Zinnias:

1. Using #2 flat, base-paint a loose oval shape with one of the following colors:
- Napthol Crimson plus Alizarin Crimson
- Turner's Yellow plus a little Pure Orange
- Turner's Yellow.

2. Blot brush and pick up a little Warm White along with base color. Stroke in small petals with chiseled edge, starting at outer edge and working in toward center.

3. Using end of brush handle, dot centers with Dioxazine Purple, then Yellow Light.

Topiary:

1. Using small flat, base-paint topiary with Dioxazine Purple plus Hauser Green Dark.

2. Using flat of brush, dab with Hauser Green Light. Wipe brush.

3. Pick up Hauser Green Light plus Yellow Citron and Warm White. Dab in highlights with this mixture.

4. Add accent color to shadow side by dabbing on a bit of Brilliant Ultramarine plus Warm White. Let dry.

Finish:

1. Following manufacturer's instructions, apply one or two light coats of sealer. Let dry.

French Market Patterns

Enlarge patterns 125%.

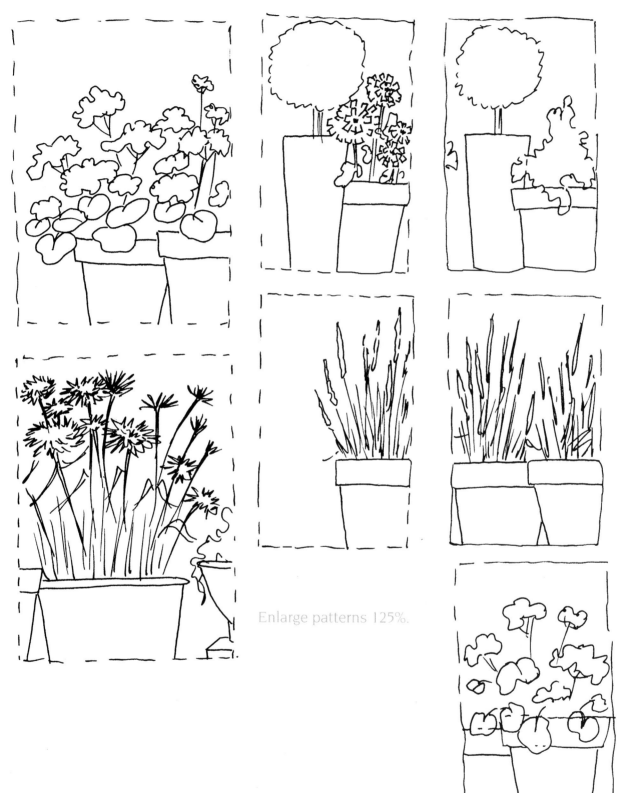

Enlarge patterns 125%.

French Market Painting Worksheet

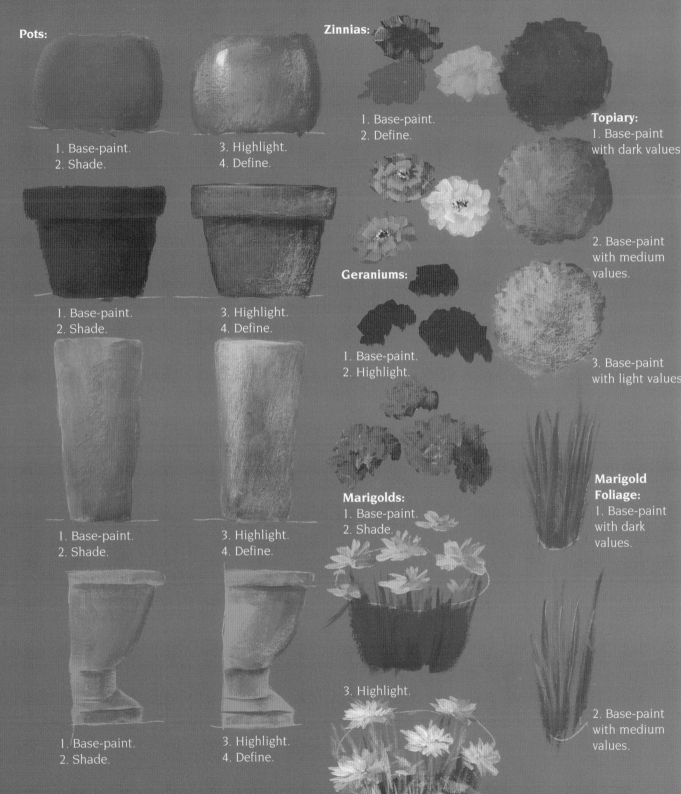

Pots:

1. Base-paint.
2. Shade.

3. Highlight.
4. Define.

1. Base-paint.
2. Shade.

3. Highlight.
4. Define.

1. Base-paint.
2. Shade.

3. Highlight.
4. Define.

1. Base-paint.
2. Shade.

3. Highlight.
4. Define.

Zinnias:

1. Base-paint.
2. Define.

Geraniums:

1. Base-paint.
2. Highlight.

Marigolds:

1. Base-paint.
2. Shade.

3. Highlight.

Topiary:

1. Base-paint with dark values.

2. Base-paint with medium values.

3. Base-paint with light values.

Marigold Foliage:

1. Base-paint with dark values.

2. Base-paint with medium values.

Toile de Jouy Chalet

Designed by
Kirsten Jones

Supplies

Project Surface:
Hexagonal wooden birdhouse
 with pointed roof

Acrylic Color:
Tapioca

Acrylic Pigment Color:
Alizarin Crimson

Brush:
Flat: #10

Other Supplies:
Crackle medium
Decoupage finish
Palette
Palette knife
Red toile de Jouy
 paper napkins
Sandpaper
Scissors
Sponge brush
Tack cloth
Tassel
Water-based outdoor sealer

Instructions

Prepare:

1. *Refer to Preparing Surfaces on pages 12–15.* Prepare birdhouse.

2. Cut out motifs from paper napkins. Separate layers from motifs.

Paint the Design:

1. Base-paint birdhouse with Tapioca. Let dry.

2. Using sponge, apple crackle medium to top and base of birdhouse. Let dry.

3. Apply topcoat with Alizarin Crimson. Cracks will form as it dries.

4. Apply motifs around sides of birdhouse with decoupage finish. Cover entire birdhouse to create the country scene.

5. Add a coat of decoupage finish around sides. Let dry.

Finish:

1. Following manufacturer's instructions, apply sealer. Let dry.

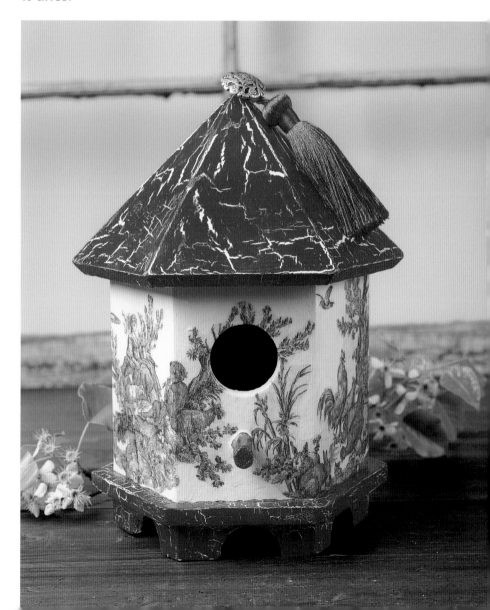

Moss Haven

Pictured on page 43.

Designed by
Mary McCullah

Supplies

Project Surface:
Wooden birdhouse with
 three-layered roof

Acrylic Colors:
Licorice
Night Sky
Parchment
Periwinkle
Wicker White

Acrylic Pigment Colors:
Asphaltum
Burnt Sienna
Green Umber
True Burgundy
Yellow Citron

Brushes:
Flats: #8, ¼", ¾"
Script liner: #1

Other Supplies:
Decoupage finish
Floral moss
Grout tape, ¼"
Hot-glue gun & glue sticks
Labels
Natural ocean sponges
Palette
Palette knife
Paper towels
Pencil
Ruler

Sandpaper
Scissors
Tack cloth
Transfer paper
Transfer tools
Water-based outdoor sealer

Instructions

Prepare:
1. Refer to Preparing Surfaces on pages 12–15. Prepare wooden birdhouse.

Paint the Design:
1. Refer to Brushes to Use on pages 8–9. Use appropriate brush type and size for area to be painted.

2. Base-paint roof with Green Umber. Base-paint birdhouse sides, front, and back with Parchment.

3. Mix a good quantity of Burnt Sienna plus True Burgundy plus Night Sky (4:4:1). Base-paint base, perch, top beam on roof, and inside rim of opening. Store the remaining mixture in a closed container like a film canister for later use.

Stripes:
Note: *Though any arrangement of vertical stripes on the sides and back is fine, the instructions describe the arrangement pictured. Stripes are made by using ¼" tape to protect the base paint between them.*
1. Begin at forward edge of each birdhouse side. Using

ruler and pencil, mark in ½", then tape vertically. Mark over ¼" more and place tape. Mark two ½" areas with tape on each side. Mark ¼" more and tape. This should place tape at the back edge. Adjust to fit birdhouse, if necessary.

2. Repeat process on back, placing a strip of tape directly in center.

3. Prepare mixture of Parchment plus Periwinkle (1:2). Using #8 flat, paint side stripes. Start with red mixture, then blue mixture, then Green Umber, and repeat. Two coats may be necessary.

4. Paint back in same manner. Let dry.

5. Remove tape strips and touch up uneven edges.

Roof:
1. Wet two pieces of sponge and squeeze dry in paper towels. Pick up Green Umber and dab sponge on palette before sponging roof. Repeat with Yellow Citron. Sponge roof alternately with Green Umber and Yellow Citron until achieving desired effect.

Birdhouse Front:
1. Refer to Transferring Patterns on page 15. Transfer Moss Haven Patterns on page 42 onto birdhouse.

Decoupaged Signs:

1. Following manufacturer's instructions, apply decoupage finish to front and back of labels. Adhere onto birdhouse front. Let dry.

2. Using liner, paint around edges and paint stakes with thinned Asphaltum.

3. Pull flowing lines for fern stems with Green Umber plus a touch of Licorice.

4. When stem lines are established, use liner tip and the dark green mixture to add leaves to stems. Simply press down and lift up on end of brush. Leave some stems free of leaves.

5. Pick up some Yellow Citron on tip of same brush. Dab over dark green leaves with tip of liner for accents. Not every leaf needs this accent.

6. Paint some vines around stakes and signs with thinned Green Umber.

7. Using brush tip, add Periwinkle flowers among ferns. Highlight with Wicker White.

8. Using liner, form cone shapes on vines to resemble morning glories with Periwinkle. Let dry.

Finish:

1. Following manufacturer's instructions, apply sealer. Let dry.

2. Hot-glue moss around birdhouse as desired.

Moss Haven Patterns

Patterns are actual size.

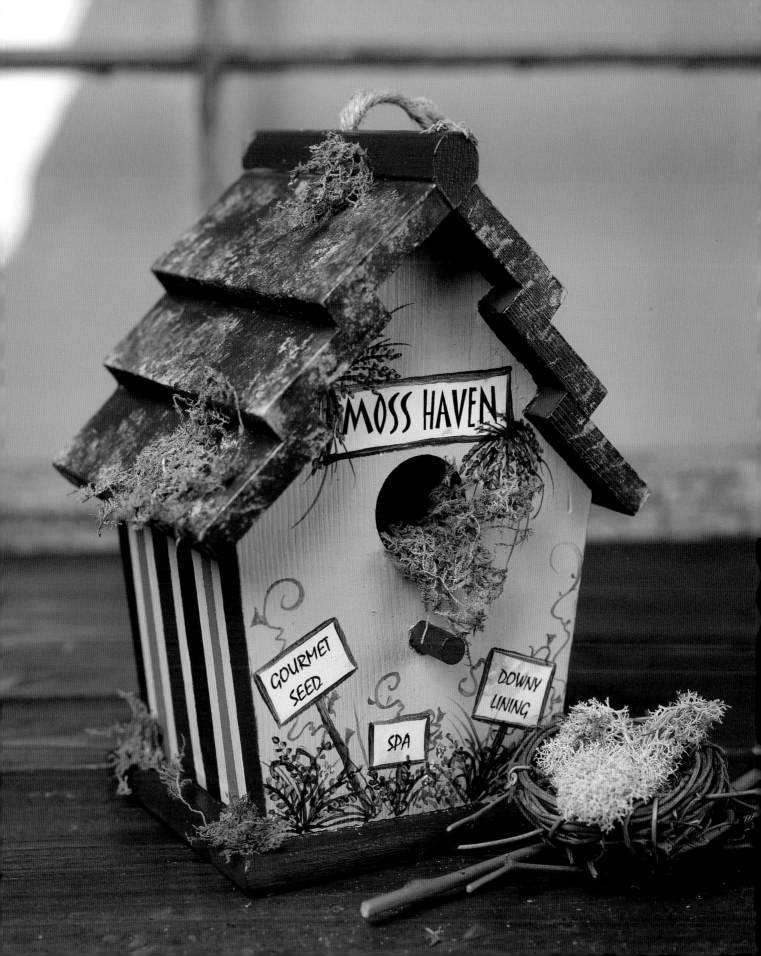

Red Barn Birdhouse

Designed by
Jacque Hennington

Supplies

Project Surface:
Barn-shaped wooden
 birdhouse

Acrylic Colors:
Butter Pecan
Engine Red
Midnight
Sunflower
Wicker White

Acrylic Pigment Colors:
Alizarin Crimson
Burnt Sienna
Burnt Umber
Yellow Ochre

Brushes:
Flat: #12
Liner: 10/0
Mini scruffy

Other Supplies:
Aluminum foil
Apple Butter Brown
 antiquing medium
Black fine-tipped
 permanent marker
Extender medium
Hot-glue gun & glue sticks
Metal ruler
Palette
Palette knife
Raffia

Sandpaper
Scissors
Soft cloth
Spray acrylic sealer
Tack cloth
Transfer paper
Transfer tools

Instructions

Prepare:

1. Refer to Preparing Surfaces on pages 12–15. Prepare birdhouse.

2. Using scissors and ruler, cut three sections from aluminum foil to cover roof. Using ruler, bend under sharp edges.

3. Hot-glue aluminum pieces to roof.

Paint the Design:

1. Refer to Brushes to Use on pages 8–9. Use appropriate brush type and size for area to be painted.

Barn:

1. Mix extender plus Alizarin Crimson. Base-paint barn with Alizarin mixture. While wet and using chiseled edge of flat, paint vertical planks with Burnt Umber and Wicker White.

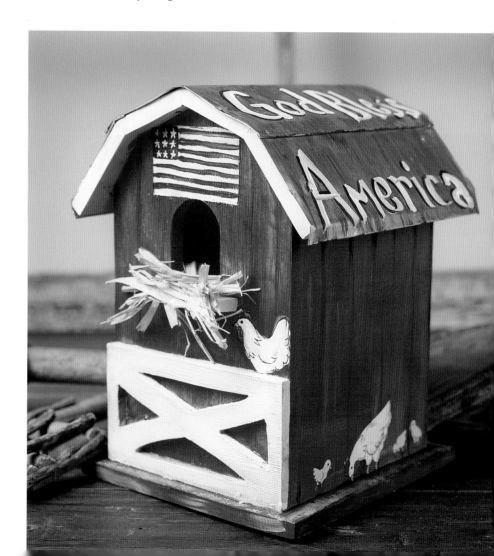

2. Base-paint base with Burnt Umber. Highlight with Wicker White and Yellow Ochre.

3. Base-paint trim, perch, and gate with Wicker White.

4. Base-paint rectangular area for flag with Wicker White.

5. Using flat, paint rust stains on roof with Burnt Sienna.

6. Refer to Transferring Patterns on page 15. Transfer Red Barn Patterns onto birdhouse.

Roof Lettering:
1. Using liner, paint lettering with Wicker White.

2. Outline lettering with Midnight.

Chickens:
1. Using flat, paint hens with Wicker White. Shade with Butter Pecan.

2. Paint crowns and wattles with Engine Red.

3. Paint legs with a mixture of Engine Red plus Sunflower.

4. Paint beaks with Sunflower.

5. Using mini scruffy, paint chicks with Sunflower.

6. Using marker, outline chickens.

Red Barn Patterns

Patterns are actual size.

Flag:
1. Using liner, paint star field on flag with Midnight. Let dry.

2. Paint stars with Wicker White.

3. Paint stripes with Engine Red. Let dry.

Finish:

1. Using soft cloth, rub antiquing medium on wooden areas (not on flag, roof, or chickens.) Let dry.

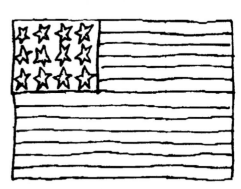

2. Spray with one or two coats of acrylic sealer. Let dry.

3. Hot-glue raffia in doorway.

Little Town Church

Designed by
Jacque Hennington

Supplies

Project Surfaces:
Wooden birdhouse
 with steeple
Wooden dowels, ⅛" dia.,
 (1¼"), (2")

Acrylic Colors:
Autumn Leaves
French Blue
Rose Garden
Sunflower
Thicket
Wicker White

Acrylic Pigment Color:
Burnt Umber

Brushes:
Flat: #12
Mini scruffy

Other Supplies:
Crackle medium
Craft glue
Drill & ⅛" bit
Floating medium
Hot-glue gun & glue sticks
Palette
Palette knife
Sandpaper
Spray acrylic sealer
Tack cloth
Transfer paper
Transfer tools

Instructions

Prepare:

1. Refer to Preparing Surfaces on pages 12–15. Prepare wooden birdhouse.

Cross:

1. Notch an area on the 2" stick where 1⅛" stick will cross. Hot-glue sticks together. Let dry.

2. Drill ¼" hole in top of steeple. Glue an end of cross into hole. Let dry.

Paint the Design:

1. Refer to Brushes to Use on pages 8–9. Use appropriate brush type and size for area to be painted.

Church:

1. Base-paint church (except rims and perches) with French Blue. Let dry.

2. Apply crackle medium to body of church and steeple. Let dry completely.

3. Paint all crackled areas with Wicker White. Cracks will form as coat dries.

4. Paint trim and perch with Sunflower.

5. Double-load flat with Wicker White and floating medium. Starting at roof bottom, paint shingles. Overlap each row. Let dry.

6. *Refer to Transferring Patterns on page* 15. Transfer Church Patterns onto birdhouse.

Topiaries:

1. Using scruffy, paint topiaries with Thicket. Highlight with Sunflower.

2. Using flat, paint pots with Autumn Leaves. Shade with Burnt Umber.

3. Paint flowers with Rose Garden and Wicker White.

Stained-glass Windows:

1. Paint windows with Burnt Umber, French Blue, Sunflower, and Wicker White.

Foliage:

1. Paint foliage with Rose Garden, Sunflower, Thicket, Wicker White. Let dry.

Finish:

1. Spray with sealer. Let dry.

Church Patterns

Enlarge patterns 150%.

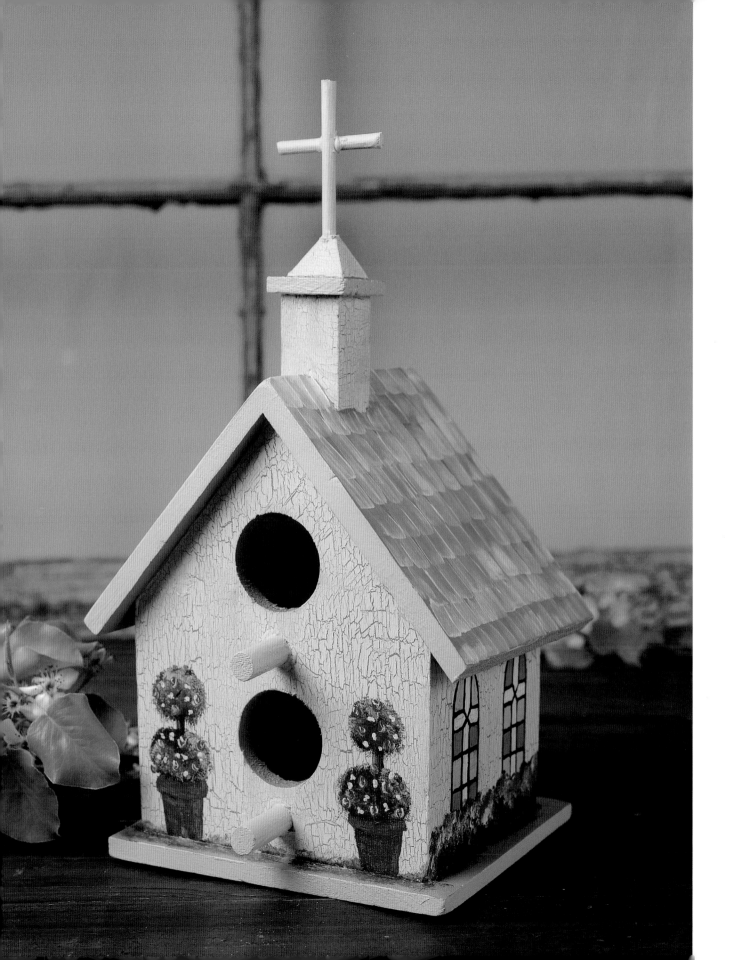

Garden Roses Birdhouse

Designed by
Ginger Edwards

Supplies

Project Surface:
Wooden birdhouse

Acrylic Colors:
Honeycomb
Lemonade
Light Peony
Lime Yellow
Poetry Green
Raspberry Wine
Thicket
Thunder Blue

Acrylic Pigment Colors:
Burnt Umber
Payne's Gray
Titanium White

Brushes:
Flats: #6, #12, #16
Liner: 10/0
Scruffy

Other Supplies:
Nails, pegs, or hooks
Palette
Palette knife
Sandpaper
Spray acrylic sealer
Tack cloth
Toothbrush
Transfer paper
Transfer tools

Instructions

Prepare:

1. *Refer to Preparing Surfaces on pages 12–15.* Prepare wooden birdhouse.

Paint the Design:

1. *Refer to Brushes to Use on pages 8–9.* Use appropriate brush type and size for area to be painted.

2. Base-paint birdhouse with Poetry Green. Paint edge of roof with Light Peony. Let dry.

3. Sand to remove some paint. Using tack cloth, wipe away sanding dust.

4. *Refer to Transferring Patterns on page 15.* Transfer Garden Roses Pattern on page 48 onto birdhouse.

Rose:

1. *Refer to Garden Roses Painting Worksheet on page 51.* Using #16 flat, fill area of rose with thinned Light Peony. While paint is wet, side-load brush with Raspberry Wine and darken color inside throat and across bottom of cup.

2. Keeping Raspberry Wine on one side of brush, side-load opposite side with Titanium White. Stroke petals. Reload brush with both colors as necessary. When all petals except the triangular-shaped petal directly in front are painted, let rose dry.

3. Using #6 flat, paint triangular-shaped petal with mixture of Light Peony plus Titanium White. Let dry.

4. "Mist" the rose sparingly with water.

5. Using side-loaded flat, deepen rose shading with small amounts of Raspberry Wine plus Payne's Gray.

6. Using scruffy flat, lightly stipple rose center with a mixture of Burnt Umber plus Raspberry Wine. Let dry.

7. Stipple highlights with Honeycomb. Intensify highlight with Lemonade plus a small amount of Honeycomb.

Leaves, Bud & Background:

1. Side-load #16 flat with mixture of Thicket plus Thunder Blue and indicate leaves. Stroke paint next to center vein area on one side of all leaves. Let dry.

2. Side-load brush with same mixture and indicate outside edges of leaves. The background will still be visible, creating the middle value. Let dry.

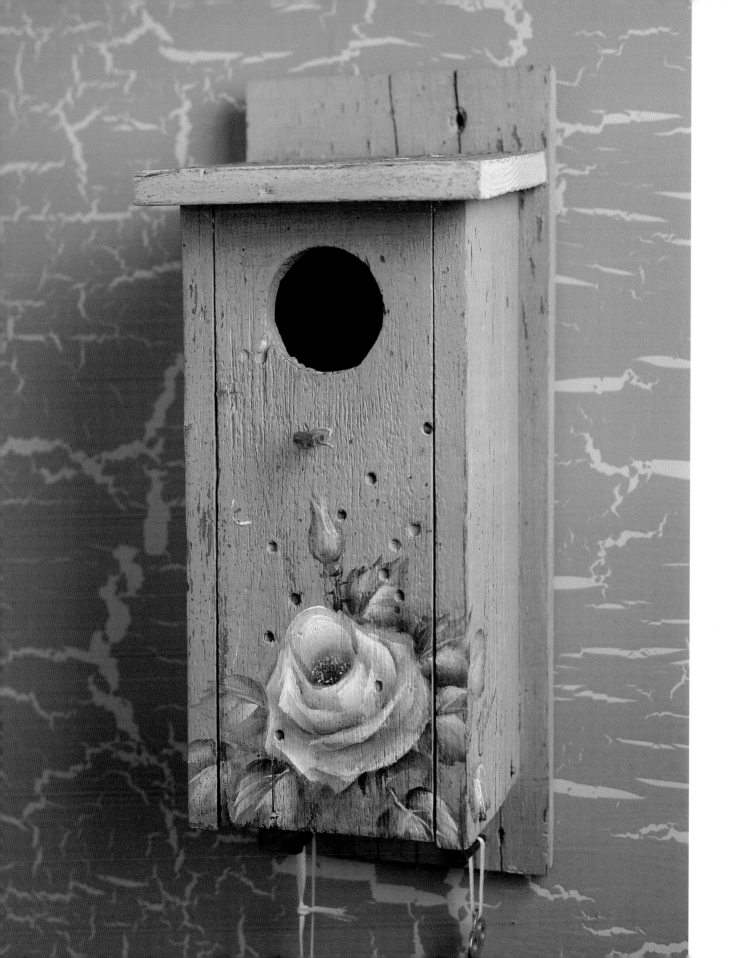

3. Using #6 flat, stroke on highlights. Load brush sparingly with Lime Yellow plus small amounts of Lemonade. Stroke color from center vein toward edges of leaves. A second coat of the highlight mixture can be stroked on if necessary. Let paint dry between coats.

4. Shade and highlight bud with same colors.

5. Using liner, paint any visible stems with Thicket plus Thunder Blue.

6. Paint center veins with mixture of Lime Yellow plus tiny amounts of Lemonade.

Paint side veins with light mixture on dark areas of leaves and Thicket plus Thunder Blue on lighter areas.

7. Paint stems with thinned Burnt Umber. Shade with Burnt Umber plus small amounts of Payne's Gray. Paint a few thorns with same mixture. Highlight sparingly with Honeycomb plus tiny amounts of Raspberry Wine and Lemonade.

8. Add color to background. Side-load #16 flat sparingly with Thicket plus Thunder Blue. Position brush so paint side is next to rose to stroke color onto background. Rinse

brush and blend lightly. Stroke thinned paint onto surface, then blend. *Note: A tiny bit of Raspberry Wine can be added to the background underneath a leaf. Very tiny amounts of Light Peony can be stroked onto the Raspberry Wine paint before it is dry. This adds "light" among the leaves.*

Finish:

1. Using toothbrush, spatter birdhouse with mixture of Thicket plus Thunder Blue thinned to a very light value.

2. "Mist" project several times with sealer. Let dry.

3. Add nails, pegs, or hooks at the bottom to hold keys.

Garden Roses Pattern

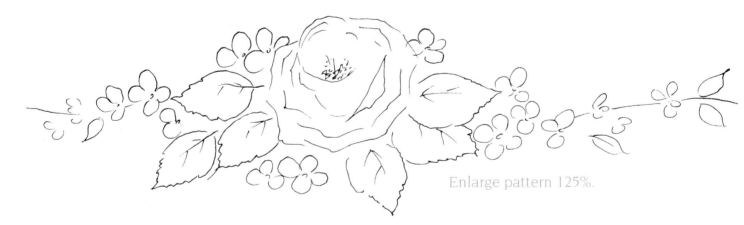

Enlarge pattern 125%.

Garden Rose Painting Worksheet

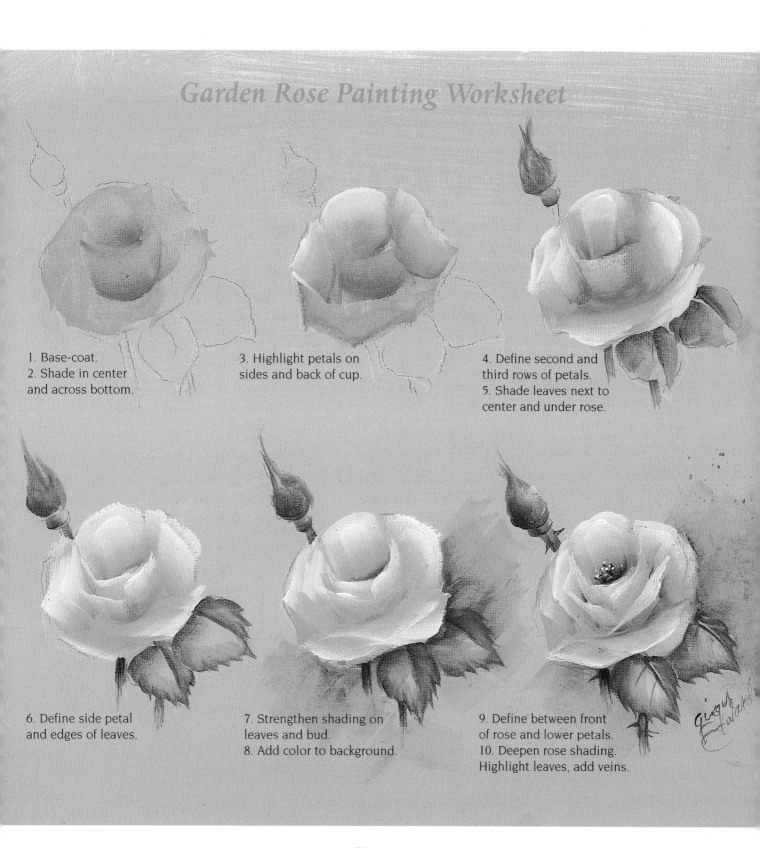

1. Base-coat.
2. Shade in center and across bottom.

3. Highlight petals on sides and back of cup.

4. Define second and third rows of petals.
5. Shade leaves next to center and under rose.

6. Define side petal and edges of leaves.

7. Strengthen shading on leaves and bud.
8. Add color to background.

9. Define between front of rose and lower petals.
10. Deepen rose shading. Highlight leaves, add veins.

Watering Can Birdhouses

Designed by
Ginger Edwards

Supplies

Project Surface:
Galvanized watering cans (2)
Wooden dowel, ⅛" dia.

Acrylic Colors:
Basil Green
Butter Pecan
Gray Green
Honeycomb
Lemon Custard
Lemonade
Lime Yellow
Old Ivy
Sunflower
Thicket
Thunder Blue

Acrylic Pigment Colors:
Burnt Umber
Ice Blue Dark
Pure Black
Titanium White
Turner's Yellow

Brushes:
Filbert whisks: ⅛", ¼"
Filberts: #4, #6
Flats: #4, #6, #8, #10
Liners: 10/0, 18/0
Round: #4
Scroller: #1

Other Supplies:
Brown antiquing medium
Drill & bits: ⅛", 1" forstner
Long screws (2)
Palette
Palette knife
Sandpaper
Screwdriver
Small piece wood (2)
Soft cloth
Sponge brush
Spray acrylic sealer
Tack cloth
Toothbrush
Transfer paper
Transfer tools

Instructions

Prepare:
1. *Refer to Preparing Surfaces on pages 12–15.* Prepare the watering cans.

2. Using 1" forstner bit, drill large opening for bird in front of each can. Drill a ⅛" hole for each perch below. Use small piece of wood inside can behind smaller hole to secure a screw for dowel perches.

Paint the Design:
1. *Refer to Brushes to Use on pages 8–9.* Use appropriate brush type and size for area to be painted.

2. Using sponge brush, apply antiquing medium. Wipe off excess with a soft cloth. Let dry.

3. Using toothbrush, spatter cans with thinned Burnt Umber. Let dry.

4. *Refer to Transferring Patterns on page 15.* Transfer Forsythia Pattern on page 54 onto the large watering can. Transfer Daffodils Pattern on page 56 onto the remaining can.

Forsythia Stems:
1. *Refer to Daffodil & Forsythia Painting Worksheet on page 55.* Using scroller, paint stems with thinned Burnt Umber.

2. Stroke shading on underside of stems.

Forsythia Leaves:
1. Base-paint leaves with Basil Green plus a small amount of Lemonade. Let dry.

2. Shade sparingly with Thicket plus tiny amounts of Burnt Umber and Thunder Blue.

3. Using filbert whisks, high-light tips with Lemonade and Lime Yellow.

Forsythia Flowers:
1. Using filbert, stroke petals with Honeycomb plus small amount Turner's Yellow. While wet, stroke a lighter value on petal tips by adding small amounts of Sunflower to the mixture. Let dry.

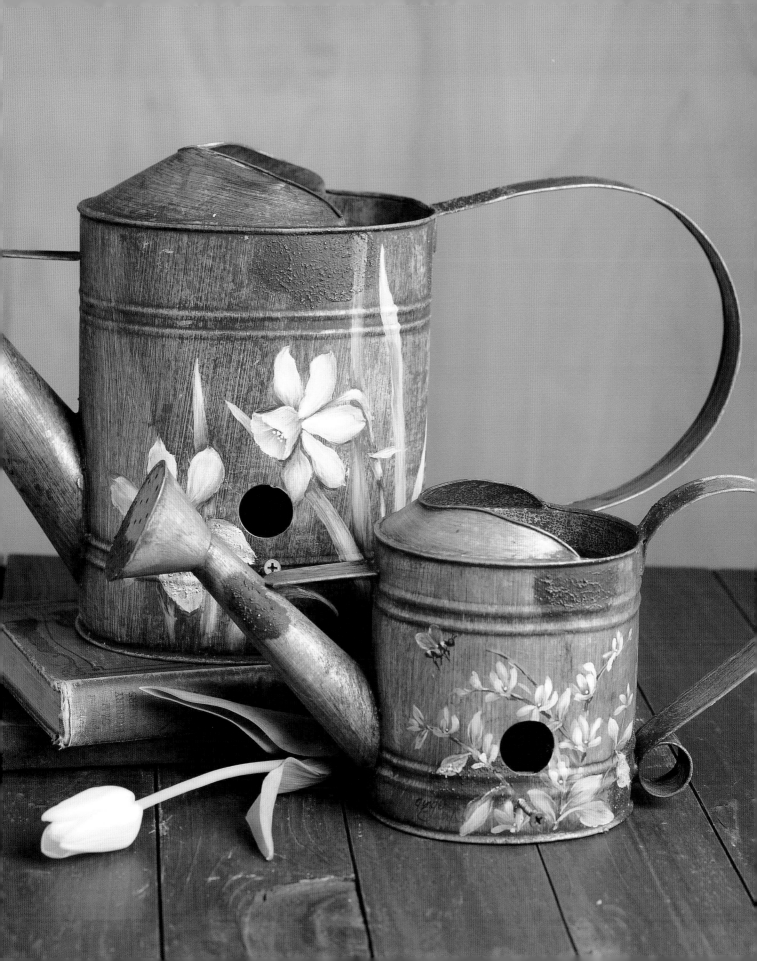

2. Using side-loaded flat, shade inside throats with Burnt Umber. Let dry.

3. Stroke some highlights with Lemonade plus small amounts of Lemon Custard.

4. Intensify highlights on a few petals with Lemonade.

5. Using end of brush handle, add tiny dot in the center of complete flowers with Lime Yellow.

Bee:
1. Paint body, head, and legs with Pure Black. Do not paint body behind the front wing. Let dry.

2. Side-load flat with either Titanium White or Pure Black (depending on background color) to paint wings. Let dry.

3. Shade to separate wings and indicate body behind front wing with inky Pure Black. Let dry.

4. Using 18/0 liner, indicate veins in wings with thinned Pure Black.

5. Paint stripes on bee with Turner's Yellow. Highlight on top with Lemonade. Let dry.

6. Stroke shading on bottom of body with inky Burnt Umber. Let dry.

Daffodil Leaves & Stems:
1. Base-paint leaves and stems with Basil Green plus small amounts of Lime Yellow. Let dry.

2. Side-load flats and shade with Old Ivy plus small amounts of Burnt Umber and Thunder Blue.

3. Highlight with Lime Yellow plus a small amount of Basil Green. Using whisks, stroke a few brighter highlights with Lime Yellow plus a small amount of Lemonade.

Forsythia Pattern

Pattern is actual size.

Daffodil & Forsythia Painting Worksheet

Daffodil:
1. Base-coat petals with two colors, blend while wet.
2. Paint stem opaquely.

3. Shade.

4. Begin highlighting flower.
5. Shade stem.

6. Stroke brightest highlights on petals. Let dry.
7. Add dots in center. Shade behind flower.
8. Highlight stem and papery membrane that covered buds.

Forsythia:
1. Paint stems and leaves opaquely.

2. Shade flower centers and at base of leaves.

3. Highlight petals.
4. Add dots in centers.
5. Highlight leaves.
6. Connect leaves to twig with stems.

4. Paint the dry, papery covering that covered the buds with Butter Pecan. Shade with a bit of Burnt Umber. Highlight with Titanium White plus a small amount of Butter Pecan.

Daffodil Flowers:

1. Base-paint and blend all petals, one petal at a time. Stroke Ice Blue Dark in shaded areas of each petal, then fill remainder of petal with Gray Green. Blend while wet.

2. Shade with Burnt Umber. Add tiny amounts of Thunder Blue for darkest shading.

3. Using flattened round, stroke Titanium White plus small amounts of Ice Blue Dark to refinish petals. Avoid a dry-brushed appearance by adding small amounts of water to paint.

4. Tint inside throats with thinned Old Ivy.

5. Brush bright highlights with Titanium White plus Lemonade.

6. Using end of brush handle, add tiny dots of Lime Yellow, then Lemonade inside throats.

Finish:

1. Following manufacturer's instructions, apply several light coats of sealer to cans.

Daffodils Pattern

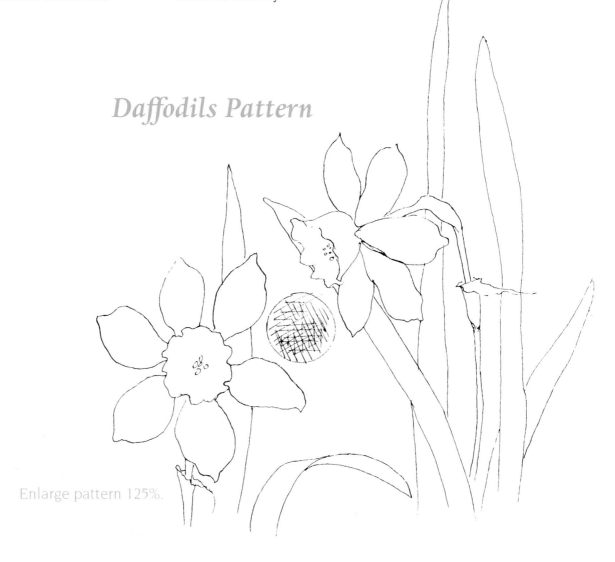

Enlarge pattern 125%.

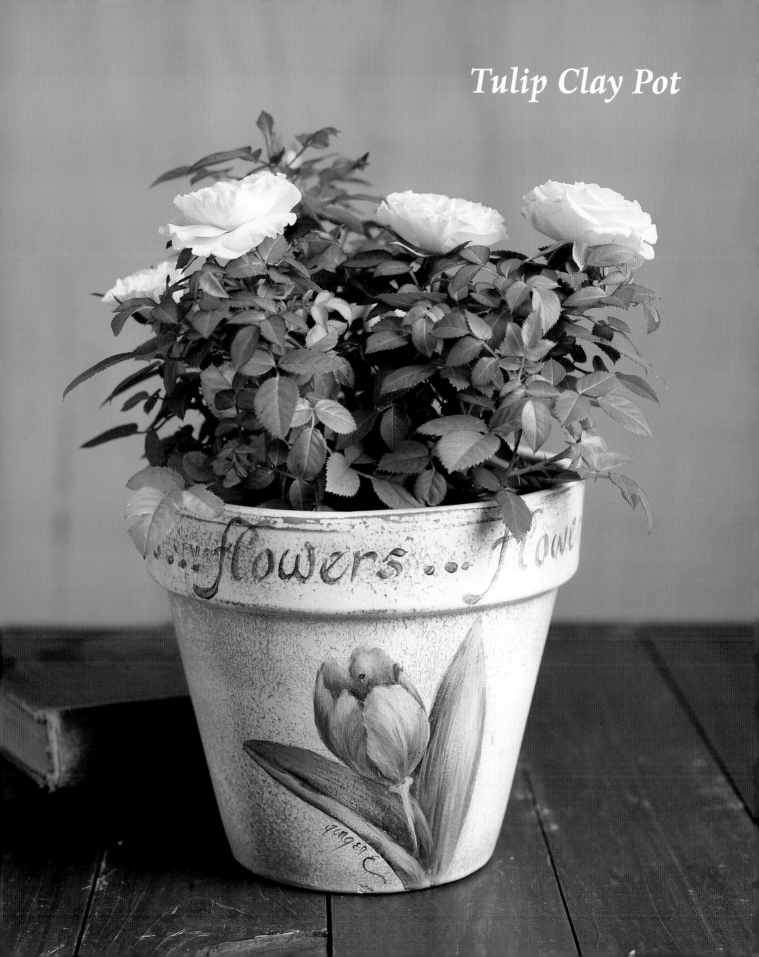

Tulip Clay Pot

Tulip Clay Pot

Pictured on page 57.

Designed by
Ginger Edwards

Supplies

Project Surface:
Clay pot, 8" dia.

Acrylic Colors:
Lemonade
Lime Yellow
Poppy Red
Raspberry Wine
Thicket
Thunder Blue
Vintage White

Acrylic Pigment Colors:
Payne's Gray
Red Light
Titanium White

Brushes:
Filbert whisk: ⅛"
Flat: #2

Other Supplies:
Antique white aerosol paint
Palette
Palette knife
Sandpaper
Spray acrylic sealer
Tack cloth
Transfer paper
Transfer tools

Instructions

Prepare:

1. *Refer to Preparing Surfaces on pages 12–15.* Prepare clay pot.

2. Spray pot with antique white. Let dry.

3. *Refer to Transferring Patterns on page 15.* Transfer Tulip Pattern on page 59 onto clay pot.

Paint the Design:

1. *Refer to Brushes to Use on pages 8–9.* Use appropriate brush type and size for area to be painted.

Leaves & Stems:

1. Base-paint surface with Thicket. While wet, stroke Lime Yellow in highlight areas and blend. Two coats may be used for more opaque coverage. Let paint dry between coats.

2. Using side-loaded flat, shade leaves and stems with Thicket plus Thunder Blue. Let dry.

3. Tint one leaf with Red Light plus Raspberry Wine.

4. Using whisk, stroke reflected light in dark areas of leaves with Titanium White plus small amounts of Payne's Gray.

5. Stroke highlights of Lemonade plus Lime Yellow. Note: *When painting leaves, do not become concerned if paints streak. Veins in leaves appear almost as streaks in real life.*

Tulips:

1. Using flat, stroke Vintage White in highlight areas of each petal and Poppy Red on remainder of each petal. Blend. Base-paint and blend one petal at a time. Two coats may be necessary for a smooth appearance. Let paint dry between applications.

Tulip Pattern

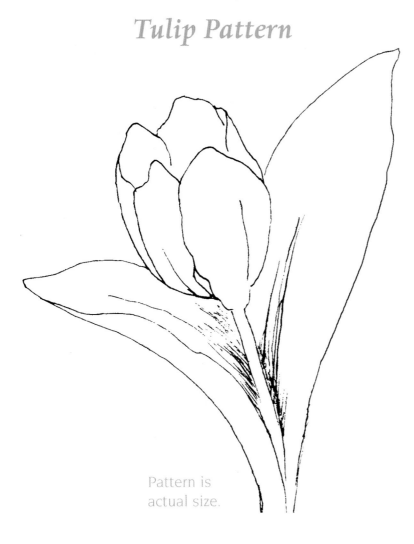

Pattern is actual size.

2. Using side-loaded flats, shade petals with Raspberry Wine. A final blending of the shading mixture with whisk will create streaks that normally appear in tulips.

3. Stroke tints onto petals with Red Light thinned to a transparent consistency.

4. Using whisk, highlight with Titanium White plus tiny amounts of Poppy Red and Lemonade. Apply a brighter highlight of Titanium White plus tiny amounts of Lemonade after the first has dried.

Lettering:
1. Using flat, paint letters with Thicket plus Thunder Blue.

Finish:

1. Following manufacturer's instructions, apply several light coats of sealer.

Wren & Forsythia Lamp

Designed by
Ginger Edwards

Supplies

Project Surface:
Clay pot, 6" dia.

Acrylic Colors:
Azure Blue
Basil Green
Butter Pecan
Honeycomb
Lemon Custard
Lemonade
Lime Yellow
Sunflower
Thicket
Thunder Blue

Acrylic Pigment Colors:
Burnt Sienna
Burnt Umber
Pure Black
Titanium White
Turner's Yellow
Warm White

Brushes:
Filbert whisk: ⅛"
Flat: #10
Liner: 18/0, 10/0

Other Supplies:
Hanging lamp kit
Palette
Palette knife
Spray acrylic sealer
Transfer paper
Transfer tools

Instructions

Prepare:

1. Refer to Preparing Surfaces on pages 12–15. Prepare clay pot.

2. Mist pot with several coats of sealer. Let dry.

3. Refer to Transferring Patterns on page 15. Transfer Wren & Forsythia Pattern onto clay pot.

Paint the Design:

1. Refer to Brushes to Use on pages 8–9. Use appropriate brush type and size for area to be painted.

Wren:

1. Refer to Wren Painting Worksheet on page 62. Using liner, paint eye with Pure Black.

2. Paint lower portion of beak with Burnt Umber plus a bit of Pure Black. Using liner and thinned paint, paint upper portion of beak with Burnt Umber plus Warm White.

3. Stroke Warm White on breast. Deepen color on throat and bottom of body with Honeycomb.

Wren & Forsythia Pattern

Pattern is actual size.

60

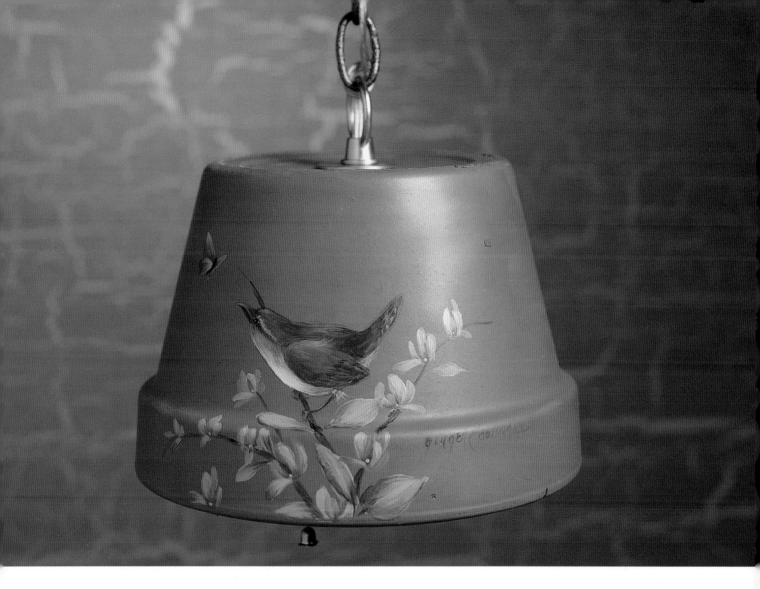

4. Paint remainder of bird with thinned Burnt Umber plus a bit of Burnt Sienna. Stroke a bit more Burnt Umber where shading occurs.

5. Using liner, paint legs and feet with thinned Burnt Umber. Let dry.

6. Using filbert, stroke top of head, back, and wing area with a mix of Butter Pecan plus a bit of Burnt Sienna and Burnt Umber. Let dry.

7. Stroke upper neck, next to eye and beak, wing, and tail feathers with Burnt Umber.

8. Using liner, shade under eye. Deepen shading on breast next to head and lower body under wing with Honeycomb plus a bit of Burnt Umber.

9. Stroke marking around eye with inky Warm White.

10. Highlight eye and beak with Warm White. Add nostril on beak with Burnt Umber.

11. Shade leg and toes with Burnt Umber plus a bit of Pure Black. Highlight toes with Warm White plus a bit of Butter Pecan.

12. Paint fluffy feathers on upper leg with Warm White.

13. Stroke small amounts of highlight on top of head, back, and upper wing with Warm White plus Butter Pecan plus a bit of Pure Black. Add markings on tail and wing feathers.

Wren Painting Worksheet

Forsythia Painting Worksheet

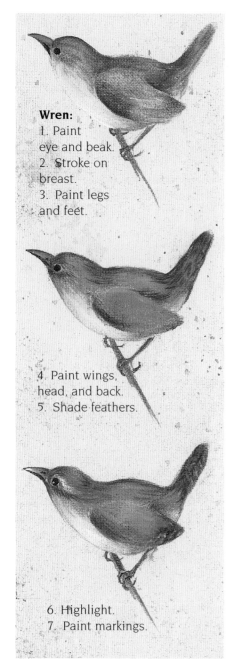

Wren:
1. Paint eye and beak.
2. Stroke on breast.
3. Paint legs and feet.

4. Paint wings, head, and back.
5. Shade feathers.

6. Highlight.
7. Paint markings.

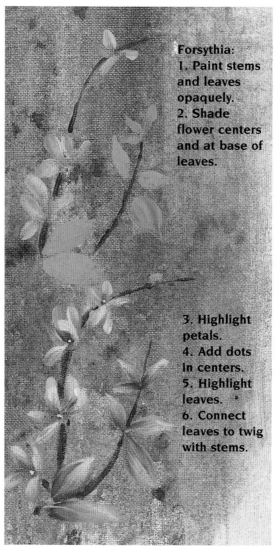

Forsythia:
1. Paint stems and leaves opaquely.
2. Shade flower centers and at base of leaves.

3. Highlight petals.
4. Add dots in centers.
5. Highlight leaves.
6. Connect leaves to twig with stems.

Butterflies:
1. Using 10/0 liner, paint bodies and antennae with Pure Black plus Burnt Umber. Let dry.

2. Sideload flat with Azure Blue plus a bit of Thunder Blue and stroke wings. Let dry.

3. Side load brush with Thunder Blue plus a bit of Azure Blue. Separate wings and deepen color on outer edges. Let dry.

4. Using whisk, highlights with Warm White plus a bit of Azure Blue.

5. Using 18/0 liner, add veins and markings on wings with thinned Thunder Blue plus Azure Blue. Paint legs with Pure Black plus Burnt Umber.

Forsythia:
1. Refer to Forsythia Painting Worksheet. Paint forsythia.

Finish:
1. Spray on sealer.

2. Following manufacturer's instructions, assemble the lamp kit.

My Prince Flowerpot

Pictured on page 65.

Designed by
Gigi Smith-Burns

Supplies

Painting Surfaces:
Clay rose pot, 6" dia.
Pine, ½" thick

Acrylic Colors:
Aspen Green
Bayberry
Coastal Blue
English Mustard
Indigo
Lemonade
Licorice
Raspberry Sherbet
Raspberry Wine
Rose Chiffon
Rose White
Settler's Blue
Slate Blue
Thicket
Wrought Iron

Acrylic Pigment Colors:
Medium Yellow
Warm White

Brushes:
Angulars: ⅜", ½"
Flats: #4, #6, #8, #10, #12, 1"
Rounds: #3, #5
Script liner: 6/0

Other Supplies:
Blending gel medium
Epoxy glue
Extender medium
Palette
Palette knife
Power saw
Sandpaper
Spray acrylic sealer
Tack cloth
Toothbrush
Transfer paper
Transfer tools

Instructions

Prepare:
1. Refer to Transferring Patterns on page 15. Transfer My Prince Patterns on page 64 onto pine and pot.

2. Cut out handle from wood.

3. Refer to Preparing Surfaces on pages 12–15. Prepare pot and wooden handle.

4. Glue handle onto flower pot. Let dry.

Paint the Design:
1. Refer to Brushes to Use on pages 8–9. Use appropriate brush type and size for area to be painted.

2. Base-paint pot with Warm White. Let dry.

Frog:
1. Base-paint frog with Bayberry.

2. Shade with Thicket. Highlight with Lemonade.

3. Reinforce previous shading with Wrought Iron. Add spots of Wrought Iron.

4. Base-paint eye iris with Medium Yellow. Highlight with Lemonade. Shade with English Mustard.

5. Outline and add lines with Licorice.

6. Base-paint pupil with Licorice and add twinkles of Warm White.

Lily Pads:
1. Base-paint pads with Aspen Green.

2. Shade with Wrought Iron. Highlight with Settler's Blue.

Water Lilies:
1. Base-paint water lilies with a mixture of Rose Chiffon plus Warm White.

2. Shade with Raspberry Sherbet. Highlight tips with Rose White.

3. Reinforce previous shading with Raspberry Wine.

4. Stroke on stems with Bayberry tipped in Wrought Iron.

Dragonflies:

1. Base-paint dragonflies with Coastal Blue plus Warm White. Shade with Coastal Blue plus a touch of Indigo.

2. Paint eyes and antennae with Licorice.

3. Paint wing veins with Indigo plus a touch of Coastal Blue.

Upper-right Butterfly:

1. Shade next to butterfly body with Coastal Blue. Shade wing edge with Raspberry Wine.

2. Using #3 round, stroke in body with Bayberry tipped into Wrought Iron.

3. Outline and add gathering lines with Licorice. Paint antennae with Licorice.

Lower-left Butterfly:

1. Base-paint butterfly wings with Coastal Blue plus Warm White.

2. Stroke in body with Bayberry tipped into Thicket.

3. Lightly outline and add gathering lines with Licorice.

Upper-left Butterfly:

1. Shade next to butterfly body with Raspberry Wine. Shade wings' outer edges with Coastal Blue plus a touch of Warm White.

2. Add gathering lines and lightly outline with Licorice.

3. Stroke in body with Bayberry tipped into Thicket.

Finish:

1. Shade behind design with Settler's Blue. Reinforce darkest areas with Slate Blue.

2. Using toothbrush, spatter with Slate Blue. Let dry.

3. Following manufacturer's instructions, apply two or more coats of sealer. Let dry.

My Prince Patterns

Enlarge patterns 220%.

64

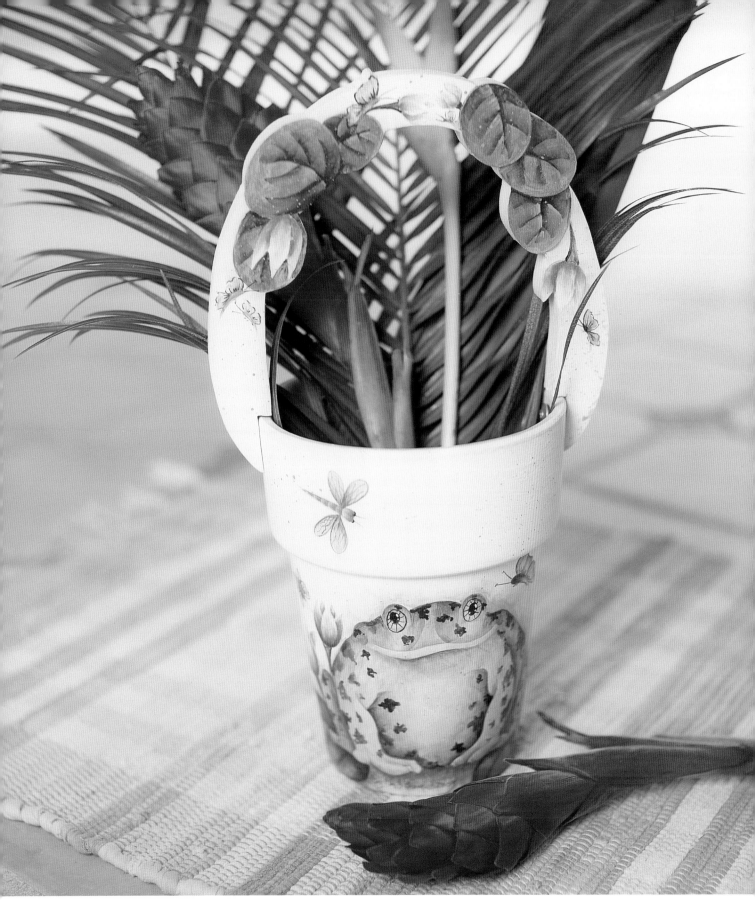

Light Up My Garden

Designed by
Gigi Smith-Burns

Supplies

Project Surfaces:
Clay azalea pot, 6½" dia.
Clay pot, 10" dia.

Acrylic Colors:
Apple Spice
Barnwood
Bayberry
Indigo
Lemonade
Licorice
Linen
Raspberry Sherbet
Settler's Blue
Tangerine
Thicket
Wicker White
Wrought Iron

Acrylic Pigment Colors:
Burnt Sienna
Burnt Umber
Warm White

Brushes:
Angulars: ⅜", ½"
Filbert: #6
Flats: #4, #6, #8, #10, #12, 1"
Rounds: #3, #5
Script liner: 6/0

Other Supplies:
Drill & carbide bit, 1"
Epoxy glue
Palette
Palette knife
Solar light kit
Toothbrush
Transfer paper
Transfer tools
Water-based outdoor sealer

Instructions

Prepare:
1. *Refer to Preparing Surfaces on pages* 12–15. Prepare pots.

Paint the Design:
1. *Refer to Brushes to Use on pages* 8–9. Use appropriate brush type and size for area to be painted.

2. Base-paint pots with Warm White. Let dry.

3. *Refer to Transferring Patterns on page* 15. Transfer Light Up My Garden Patterns on page 69 onto clay pots.

Bricks:
1. Using flats, lightly stroke in hints of bricks with Barnwood.

Seagulls:
1. Base-paint seagulls with Settler's Blue.

2. Highlight down body and wings with Wicker White.

3. Using liner, line with Licorice.

Windows:
1. Base-paint windows with Lemonade.

2. Shade tops with Tangerine.

3. Using double-loaded brush, paint frame with Indigo and Settler's Blue.

Door:
1. Base-paint door with Apple Spice.

2. Shade top and left edge with Burnt Umber. Reinforce with mixture of Burnt Umber and Indigo.

3. Highlight right side of door with mixture of Apple Spice and Warm White.

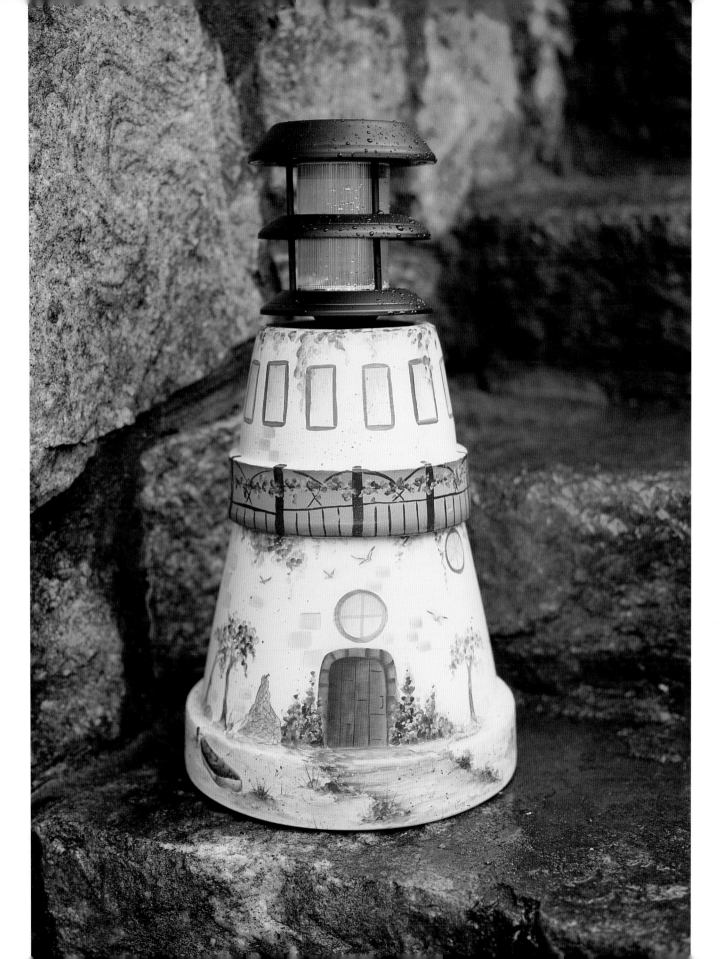

4. Outline door with Licorice.

5. Base-paint around door with Settler's Blue. Shade with Indigo.

Trees:

1. Wash tree trunks with Burnt Umber. Shade with Wrought Iron.

2. Stipple tree greenery with Bayberry, Thicket, and Wrought Iron.

Foliage:

1. Stipple foliage with Bayberry, Thicket, and Wrought Iron. Note: *Do not use Wrought Iron on foliage on top pot.*

2. Using end of brush handle, dot around door with Raspberry Sherbet and Tangerine.

Path:

1. Randomly wash path with Barnwood, Linen, and Settler's Blue.

2. Add tints of Burnt Umber and Warm White. Be certain to paint some in a horizontal direction.

Boat:

1. Wash boat with Burnt Sienna.

2. Base-paint oars and seats with Burnt Sienna.

3. Shade bottom edges of boat and inside boat next to left top edge with Burnt Umber.

4. Reinforce shading on inside of boat with mixture of Burnt Umber and Licorice.

Net:

1. Randomly wash net with Barnwood and Linen and mixture of Burnt Umber and Thicket.

2. Line netting with Licorice.

Post:

1. Base-paint post with Burnt Umber.

2. Shade with Burnt Umber and Indigo.

Grass & Ground:

1. Add grass and ground line work with Bayberry, Burnt Umber, Thicket, and Wrought Iron.

2. Shade with same colors underneath some grasses.

3. Add washes of Burnt Sienna, Burnt Umber, Settler's Blue, and Thicket throughout ground area.

Finish:

1. Paint rim on top pot with Settler's Blue. Shade along edge with Indigo.

2. Using liner, paint fence line with Licorice.

3. Add Tangerine flowers.

4. Using toothbrush, spatter pots with Burnt Umber.

5. Spatter ground area on bottom pot with Burnt Sienna, Burnt Umber, and Linen.

6. Following manufacturer's instructions, apply two or more coats of sealer.

7. Glue pots together.

8. Following manufacturer's instructions, install solar light.

Light Up My Garden Patterns

Continue design
around azalea pot.

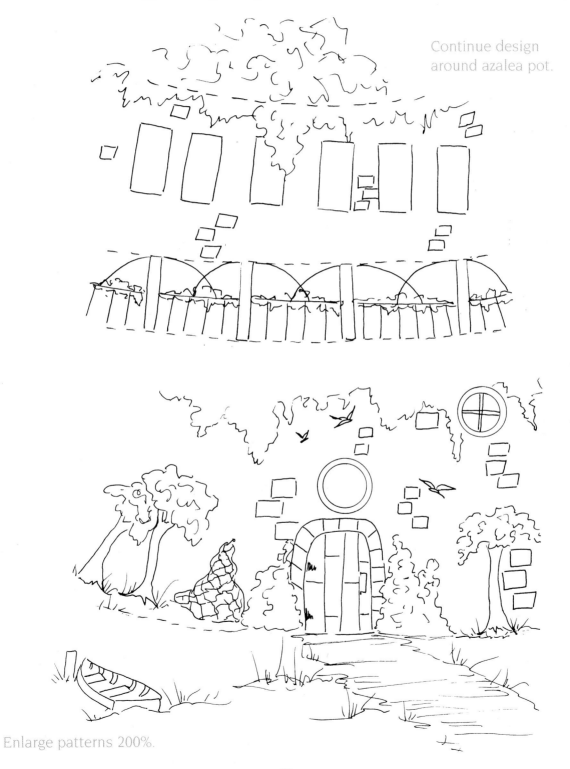

Enlarge patterns 200%.

Home Sweet Home Candleholder

Designed by
Gigi Smith-Burns

Supplies

Project Surfaces:
Clay rose pot, 4" dia,
Clay saucers: 4" dia., 6" dia.

Acrylic Colors:
Barn Wood
Bayberry
Blue Bell
Buttercrunch
Ivory White
Lemonade
Licorice
Raspberry Sherbet
Raspberry Wine
Rose Chiffon
Rose White
Slate Blue
Thicket
Wrought Iron

Acrylic Pigment Colors:
Burnt Sienna
Burnt Umber
Warm White

Brushes:
Angulars: ⅜", ½"
Flats: #4–#12, 1"
Rounds: #3, #5
Script liner: 6/0

Other Supplies:
Drill & drill bits (optional)
Extender medium
Palette
Palette knife
Toothbrush
Transfer paper
Transfer tools
Water-based outdoor sealer
Waterproof glue

Instructions

Prepare:

1. Refer to Preparing Surfaces on pages 12–15. Prepare pot and saucers.

2. If desired, drill a hole opening for bird .

Paint the Design:

1. Refer to Brushes to Use on pages 8–9. Use appropriate brush type and size for area to be painted.

2. Base-paint all pieces with Warm White. Let dry.

3. Refer to Transferring Patterns on page 15. Transfer Home Sweet Home Patterns on pages 72–73 onto pot and saucers.

Bird:

1. Base-paint bird body with Blue Bell.

2. Shade with Slate Blue.

3. Highlight with Warm White plus a touch of Blue Bell.

4. Stroke in wing feathers and tail feathers with Blue Bell plus Warm White.

5. Paint beak with Buttercrunch. Shade with Burnt Sienna.

6. Paint eyes with Licorice.

Branches:

1. Wash branches with Barn Wood.

2. Randomly shade with Wrought Iron.

Leaves:

1. Base-paint leaves with Bayberry. Shade base and down center vein with Thicket.

2. Highlight with Lemonade.

3. Add tints of Rose Chiffon.

4. Deepen shading with Wrought Iron.

5. Using liner, add veins and loosely outline with Wrought Iron.

Hole & Perch:

Note: *The following painting steps are not necessary if you drilled a hole in the pot.*
1. Wash hole with Burnt Sienna. Shade all around with Burnt Umber.

2. Deepen shading on sides and bottom with Licorice.

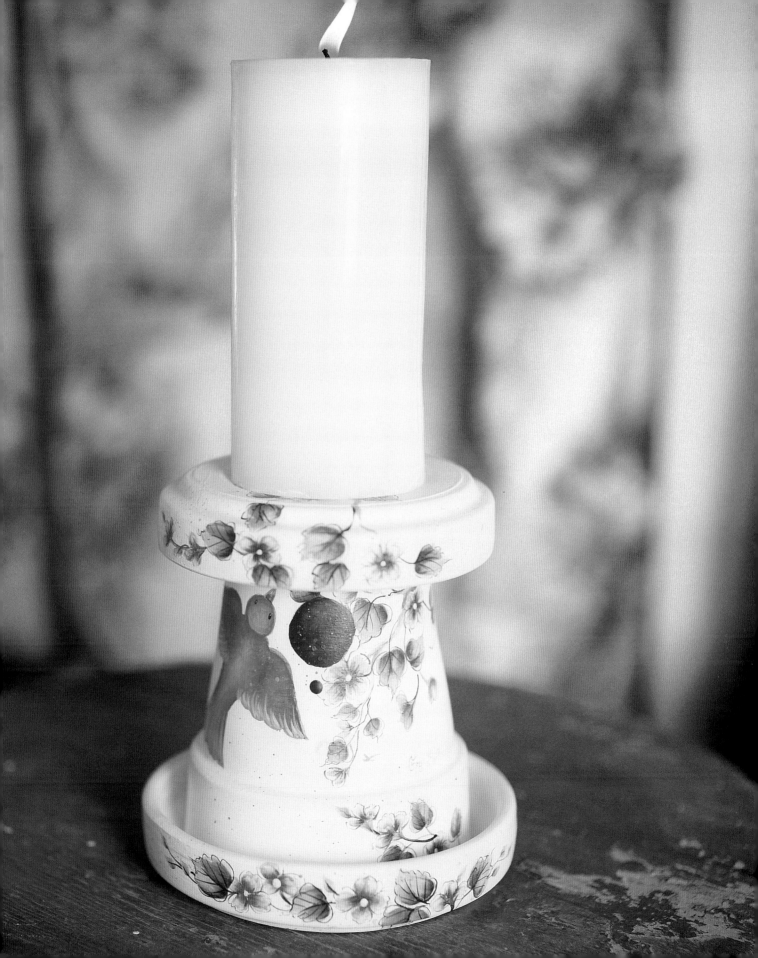

3. Using end of brush handle, dot perch with Burnt Umber.

Blossoms:
1. Base-paint flowers with Rose Chiffon plus Warm White.

2. Shade petal bases with Raspberry Sherbet.

3. Highlight petal edges with Ivory White.

4. Deepen shading at petal bases with Raspberry Wine.

5. Outline petals with Raspberry Sherbet. Using brush handle, add dots of Buttercrunch for the centers.

Finish:
1. Using toothbrush, spatter all pieces with Blue Bell. Let dry.

2. Glue pieces together. Let dry.

3. Following manufacturer's instructions, apply two or more coats of sealer. Let dry.

Home Sweet Home Pattern

Pattern is actual size.

Home Sweet Home Patterns

Patterns are actual size.

Tweet's Shop Bird Feeder

Designed by
Sue Bailey

Supplies

Project Surfaces:
Small wooden bird
Wooden bird feeder

Acrylic Colors:
Licorice
Sky Blue
True Blue
Wicker White

Acrylic Pigment Colors:
Burnt Sienna
Burnt Umber
Medium Yellow
Raw Sienna
Red Light

Brushes:
Flats: #4–#12
Liner: 10/0
Scroller

Other Supplies:
Palette
Palette knife
Sandpaper
Spray acrylic sealer
Tack cloth
Transfer paper
Transfer tools

Instructions

Prepare:

1. Disassemble front sign and front roof. Also remove glass.

2. Refer to Preparing Surfaces on pages 12–15. Prepare wooden pieces.

Paint the Design:

1. Refer to Brushes to Use on pages 8–9. Use appropriate brush type and size for area to be painted.

2. Base-paint inside and out with Sky Blue.

3. Base-paint sign and sides of bird feeder bottom with True Blue. Let dry.

4. Refer to Transferring Patterns on page 15. Transfer Tweet's Shop Patterns on page 76 onto sides of birdhouse and onto sign.

Mother Bird:
1. Base-paint head, back, and wings with True Blue.

2. Paint breast with Burnt Sienna plus Wicker White.

3. Rewet with True Blue plus Wicker White and "chop" onto head and wings to suggest feathers.

4. Paint beak and eye with Licorice. Highlight with Wicker White. Paint a line under and over eye with Wicker White.

5. Base-paint berry stems in mouth with Licorice plus Medium Yellow. Highlight with Wicker White.

6. Using end of brush handle, add dots with Red Light for berries.

Baby Birds:
1. Chop on each breast and back with Burnt Sienna plus Wicker White.

2. Chop on head and back with True Blue plus Wicker White. Let some breast color show through randomly.

3. Paint open mouth with Burnt Sienna and Wicker White. Paint center with Burnt Umber. Outline with Wicker White.

4. Paint eye with Licorice. Dot Wicker White for highlight. Outline around eye with Wicker White.

Branches:
Note: Use choppy strokes.
1. Base-paint branches with Raw Sienna.

2. Shade with Burnt Umber.

3. Highlight with Raw Sienna plus Wicker White.

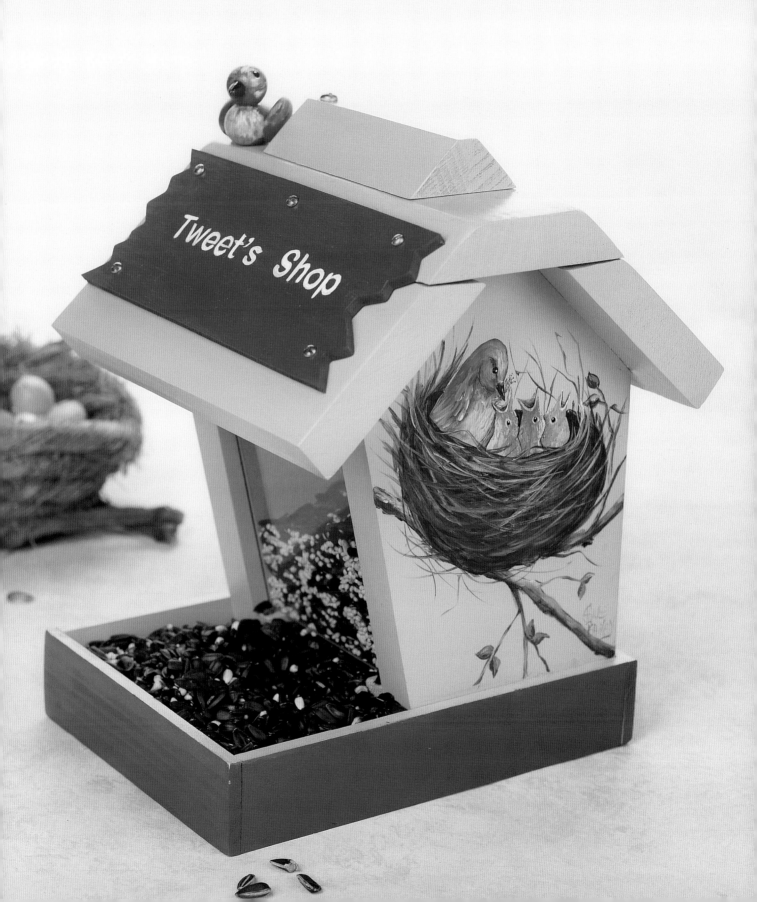

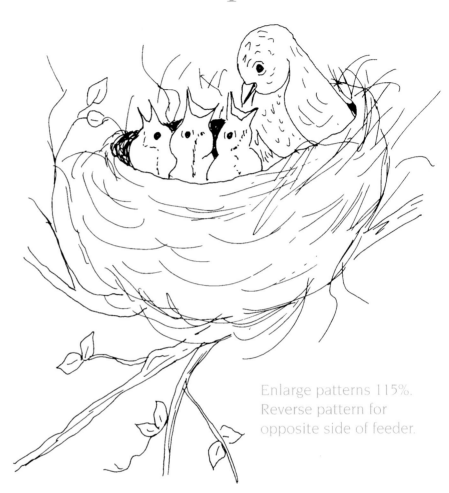

Leaves:

1. Base-paint leaves with a mixture of Licorice plus Medium Yellow.

2. Lighten top part of leaf with Medium Yellow plus Wicker White.

Nest:

1. Very loosely paint nest with Burnt Umber. Streak outside lines and crisscross with Burnt Umber.

2. Using scroller, paint straw outside of nest with Burnt Umber. Using dirty brush, crisscross over entire nest.

3. Pick up Raw Sienna and Raw Sienna plus Wicker White and repeat procedure for color variation and highlights.

Sign:

1. Using liner, paint lettering on sign with Wicker White.

Small Wooden Bird:

1. Chop in Burnt Sienna plus Wicker White on breast.

2. Paint remainder of bird with True Blue.

Enlarge patterns 115%. Reverse pattern for opposite side of feeder.

Tweet's Shop

3. Suggest feathers with True Blue plus Wicker White and Wicker White.

4. Paint beak and eyes with Licorice. Highlight with Wicker White. Let dry.

Finish:

1. Spray inside of feeder, sign, little bird, and outside of feeder with sealer. Let dry.

2. Reassemble glass, roof, and sign.

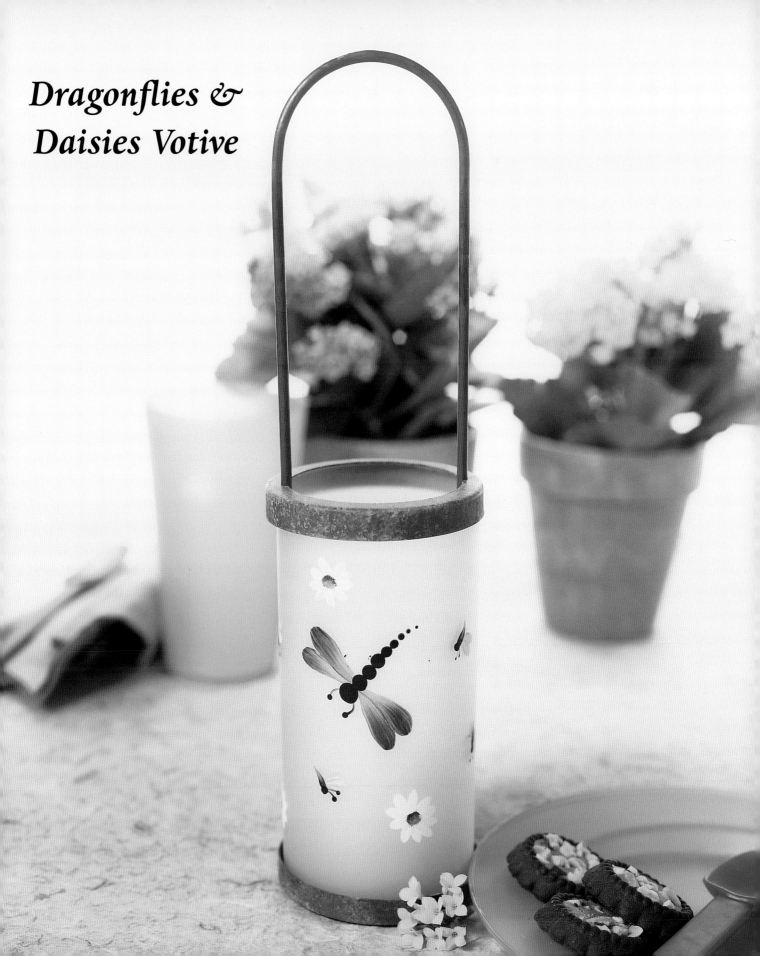

Dragonflies &
Daisies Votive

Dragonflies & Daisies Votive

Pictured on page 77.

Designed by
Rachel Wright

Supplies

Project Surface:
Glass chimney votive,
3" dia. x 5¼" tall

Acrylic Colors:
Bright Baby Pink
French Blue
Fuchsia
Licorice
Night Sky
Purple Lilac
Violet Pansy
Wicker White

Acrylic Pigment Colors:
Burnt Sienna
Turner's Yellow

Brushes:
Liner: #20/0
Rounds: #2, #4

Other Supplies:
Extender medium
Palette
Palette knife
Sandpaper
Stylus
Tack cloth
Transfer paper
Transfer tools

Instructions

Prepare:
1. Remove glass from holder.

2. Refer to Preparing Surfaces on pages 12–15. Prepare votive.

Paint the Design:
1. Refer to Brushes to Use on pages 8–9. Use appropriate brush type and size for area to be painted.

2. Refer to Transferring Patterns on page 15. Transfer Dragonflies & Daisies Patterns on page 79 onto votive.

3. Mix the following paints with extender (2 drops extender for dime-sized puddle of paint):
- Bright Baby Pink
- French Blue
- Fuchsia
- Night Sky
- Purple Lilac
- Turner's Yellow
- Violet Pansy
- Wicker White.

Dragonflies:
1. Fully load #4 round with Bright Baby Pink. Dip bristle tips in Fuchsia. Paint pink wings, stroking from outside toward center of body.

2. Fully load brush with French Blue and tip in Night Sky. Stroke blue wings.

3. Fully load brush with Purple Lilac and tip in Violet Pansy. Stroke purple wings.

4. Using brush handle and working from top to bottom, dot bodies with Licorice.

5. Using liner, paint antennae with inky Licorice.

6. Using stylus, dot antennae ends with Licorice.

Yellow Butterflies:
1. Fully load #2 round with Turner's Yellow and tip color in Wicker White. Stroke wings.

2. Stroke bodies with Licorice. Using brush handle, dot heads with Licorice.

3. Using liner, paint antennae with Licorice.

4. Using stylus, dot antennae ends with Licorice.

Daisies:
1. Fully load #2 round with Wicker White. Stroke daisy petal, working from outside toward center.

2. Load tips of dry bristle brush with Burnt Sienna. Pick up Turner's Yellow on a small section of tips. Pounce daisy centers. Let dry.

Finish:
1. Place glass inside holder.

Dragonflies & Daisies Patterns

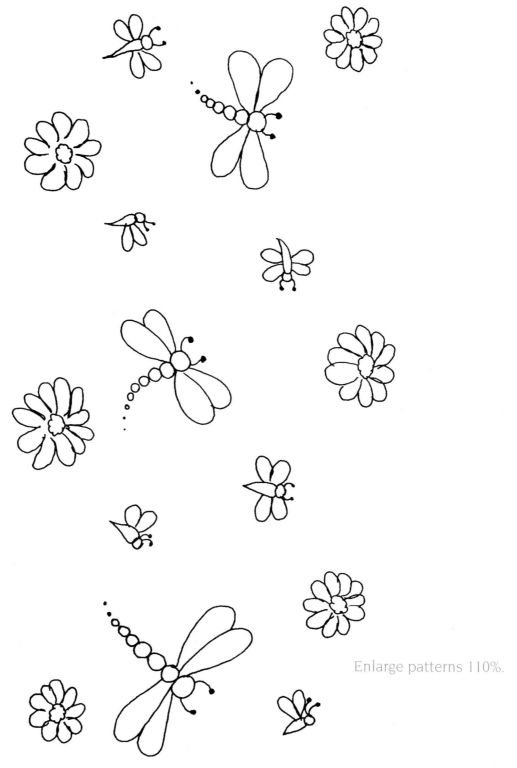

Enlarge patterns 110%.

Birdhouses Shelf

Designed by
Sue Bailey

Supplies

Project Surfaces:
Wooden shelf with birdhouses
Wooden signs (2)

Acrylic Colors:
Barn Wood
Licorice
Navy Blue
Sky Blue
Slate Blue
True Blue
Wicker White

Acrylic Pigment Colors:
Burnt Sienna
Burnt Umber
Christmas Red
Medium Yellow
Raw Sienna

Brushes:
Flats: #6, #10
Liner: 10/0
Scroller: #1

Other Supplies:
Ice pick
Palette
Palette knife
Sandpaper
Spanish moss
Spray acrylic sealer
Tack cloth
Transfer paper
Transfer tools
Wire, thin (1')

Instructions

Prepare:
1. *Refer to Preparing Surfaces on pages 12–15.* Prepare wooden surfaces.

Paint the Design:
1. *Refer to Brushes to Use on pages 8–9.* Use appropriate brush type and size for area to be painted.

2. Base-paint top of shelf and roofs of birdhouses with Navy Blue. Paint background with Sky Blue. Paint birdhouses with Slate Blue. Let dry.

3. *Refer to Transferring Patterns on page 15.* Transfer Birdhouses Patterns on page 83 onto shelf.

Branches:
Note: *Use choppy strokes to create texture.*
1. Base-paint branches with Raw Sienna. Shade with Burnt Umber. Highlight with Raw Sienna plus Wicker White.

Leaves:
Note: *Leaves and limbs continue on birdhouse sides.*
1. Base-paint leaves with Licorice plus Navy Blue. Pull Medium Yellow and Medium Yellow plus Wicker White from outer edge of each leaf inward toward vein line. Lighten next to vein with Wicker White plus Medium Yellow and Wicker White.

2. Add tints of True Blue and True Blue plus Wicker White.

Nest:
1. Loosely base-paint nest with Burnt Umber.

2. Using scroller, crisscross and pull out strokes onto background with Burnt Umber and Raw Sienna plus Wicker White.

Baby Birds:
Note: *Make the baby birds look like they have very few feathers.*
1. Base-paint each body with Burnt Sienna plus Wicker White.

2. Paint from top of head down back and some on body with Licorice plus True Blue plus Wicker White.

3. Using liner, suggest a few feathers on head and back with Wicker White and gray mixture.

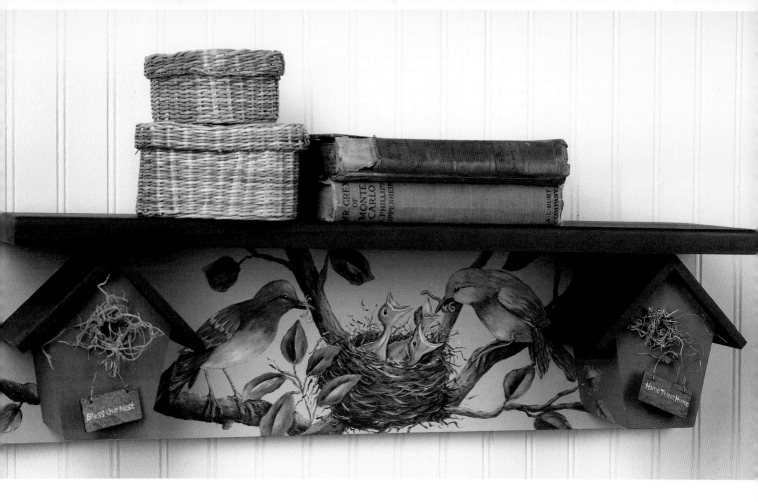

4. Paint eyes with Licorice. Using end of brush handle, add dots with Wicker White. Add a Wicker White line above each eye and under each eye.

5. Paint inside mouths with Medium Yellow. Shade with Burnt Sienna. Highlight with Wicker White. Outline with Wicker White.

Mother Bird (on right):

1. Refer to Birdhouses Painting Worksheet on page 85. Using choppy strokes, base-paint head, back, and neck with Barn Wood plus a touch of Licorice.

2. Add tints with Medium Yellow and True Blue.

3. Base-paint wings and tail feathers with True Blue.

4. Shade with True Blue plus Licorice. Highlight with True Blue plus Wicker White.

5. Outline with Licorice.

6. Base-paint breast with Burnt Sienna.

7. Using choppy strokes, shade with Burnt Sienna plus Burnt Umber. Highlight with Burnt Sienna plus Wicker White. Add tints of Medium Yellow.

8. Base-paint legs and feet with Barn Wood. Shade with Barn Wood plus Licorice.

9. Paint lines with Wicker White.

10. Base-paint claws with Licorice. Highlight with Wicker White.

11. Shade under bird, legs, and feet with Burnt Umber.

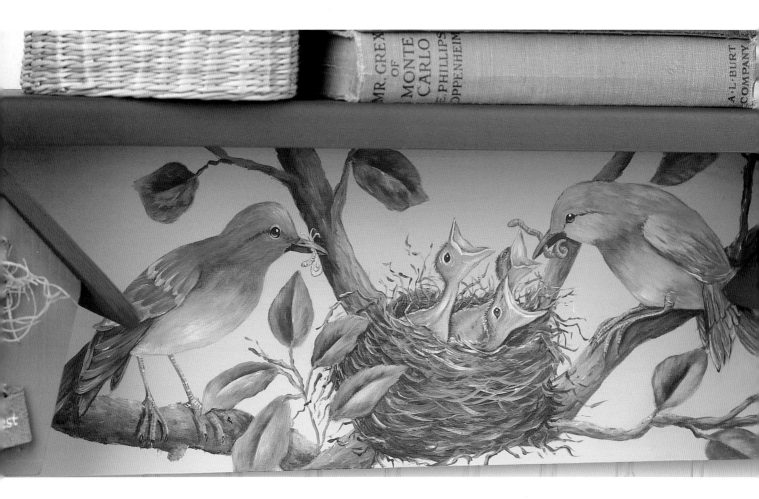

12. Base-paint beak with Licorice. Highlight on top with Wicker White.

13. Base-paint eye with Licorice. Lighten bottom with Barn Wood.

14. Add a Wicker White highlight dot. Paint detail out from eye with Licorice.

15. Base-paint worm in bird's mouth with Christmas Red. Shade with Christmas Red plus Burnt Umber. Highlight with Wicker White.

Father Bird (on left):

1. Using choppy strokes, base-paint head, back, wings, and tail feathers with True Blue.

2. Highlight with Wicker White. Paint detail with Licorice and Wicker White.

3. Base-paint breast with Burnt Sienna. Highlight with Burnt Sienna plus Wicker White, Wicker White plus Medium Yellow, and Wicker White.

4. Paint legs, feet, and claws with Barn Wood. Shade with Barn Wood plus Licorice.

5. Shade under feet with Burnt Umber.

6. Paint eye with Licorice. Lighten iris at bottom with Barn Wood. Using end of brush handle, dot with Wicker White.

Birdhouses Patterns

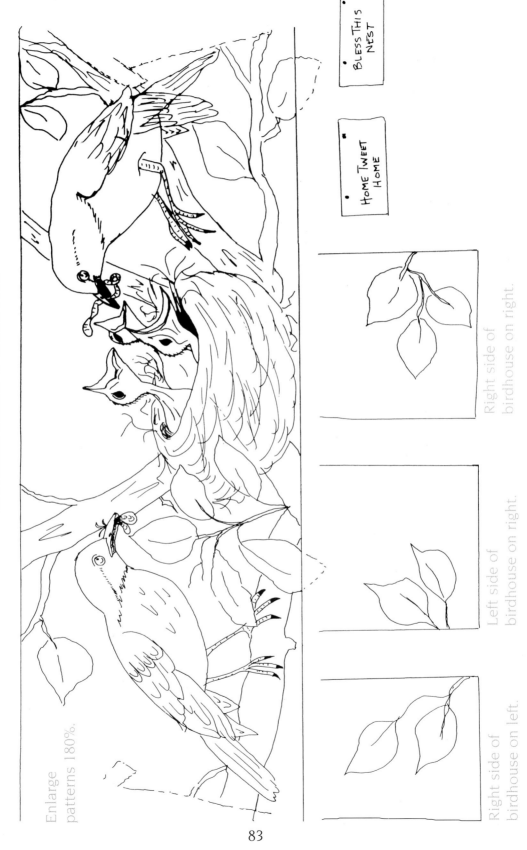

Enlarge patterns 180%.

BLESS THIS NEST

HOME TWEET HOME

Right side of birdhouse on right.

Left side of birdhouse on right.

Right side of birdhouse on left.

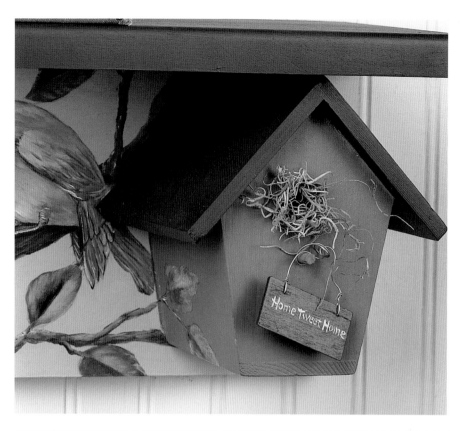

7. Add a Wicker White line above eye and at bottom of eye. Paint detail out from eye with Licorice.

8. Base-paint beak with Licorice. Highlight on top with Wicker White.

9. Paint bug in beak with Wicker White plus a touch of Medium Yellow and Wicker White. Paint detail with Licorice.

Small Signs:

1. Paint signs with Navy Blue.

2. Paint letters with Sky Blue. Let dry.

Finish:

1. Using ice pick, punch small holes into tops of signs. Run wire through holes. Twist wire ends together and hang sign onto perch of each birdhouse.

2. Following manufacturer's instructions, apply sealer. Let dry.

3. Fill birdhouse holes with Spanish moss.

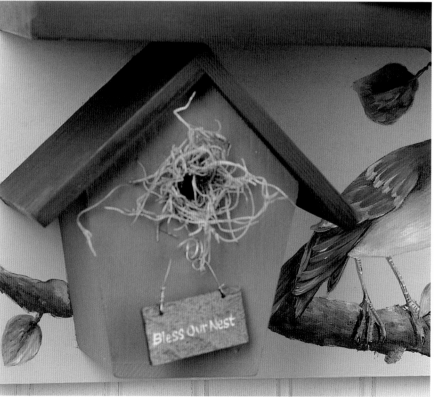

Birdhouses Painting Worksheet

Male Bluebird:
1. Base-paint.

Female Bluebird:
1. Base-paint.

2. Highlight.

2. Highlight.

3. Detail.

3. Detail.

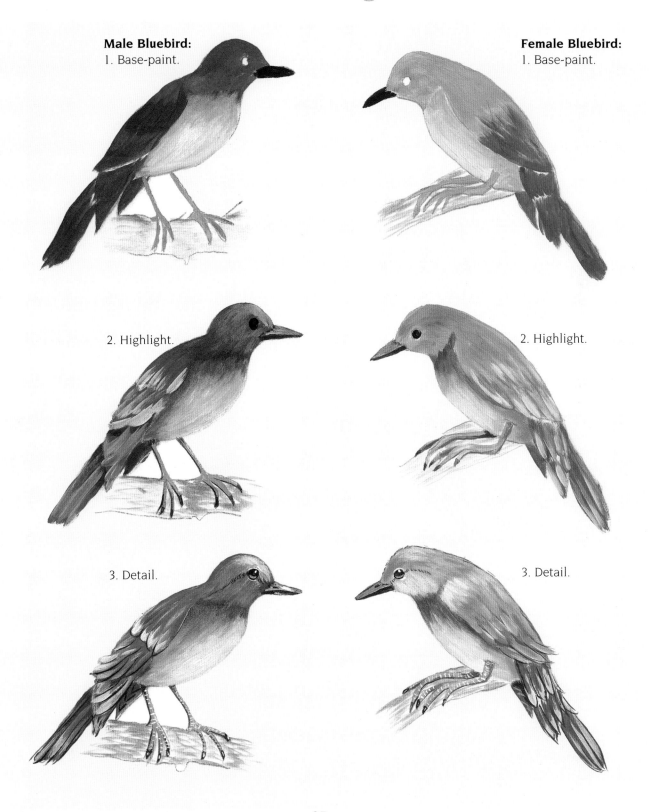

Harvest Bucket

Designed by
Sandy Dye

Supplies

Project Surface:
Galvanized bucket,
 5½" dia. x 6" tall

Acrylic Colors:
Buttercup
Country Twill
English Mustard
Glazed Carrots
Grass Green
Licorice
Maple Syrup
Thicket

Acrylic Pigment Colors:
Burnt Sienna
Burnt Umber
True Burgundy
Warm White

Brushes:
Angular: ⅜"
Filbert: #8
Flats: #6, #10
Liner: 10/0
Rounds: #2, #4
Sponge
Stippler

Other Supplies:
Crackle medium
Floating medium
Palette
Palette knife
Paper towels
Transfer paper
Transfer tools
Water-based outdoor sealer

Instructions

Prepare:

1. *Refer to Preparing Surfaces on pages* 12–15. Prepare bucket.

2. Apply crackle medium to bucket exterior. Let dry.

Paint the Design:

1. *Refer to Brushes to Use on pages* 8–9. Use appropriate brush type and size for area to be painted.

2. Base-paint bucket with Licorice. Let dry. Cracks will form.

3. Following manufacturer's instructions, apply a coat of sealer. Let dry.

4. *Refer to Transferring Patterns on page* 15. Transfer Harvest Pattern on page 88 onto bucket.

Pumpkins:

1. *Refer to Harvest Painting Worksheet on page* 89. Base-paint the pumpkins with English Mustard plus Glazed Carrots (1:2).

2. Base-paint leaves with Grass Green.

3. Base-paint cattails with Maple Syrup.

4. Base-paint pumpkin stems with Country Twill.

5. Load angular with floating medium and blot on paper towel. Pick up a bit of True Burgundy in corner and blot again. Paint small and larger pumpkins' ridges.

6. Dry-brush between ridges with Buttercup.

Stems:

1. Dip angular in floating medium and blot. Pick up a bit of Maple Syrup in the corner and blot again. Shade stems.

2. Using liner, add a few ridges to stems with Maple Syrup.

Leaves:

1. Using #6 flat paint leaves with Thicket.

2. Dip clean brush in floating medium, blot, and pick up just a bit of Licorice in one corner. Blot, paint veins, and shade.

Cattails:

1. Using corner of angular, shade left sides of cattails with a bit of Country Twill.

2. Using liner, highlight on right with Warm White.

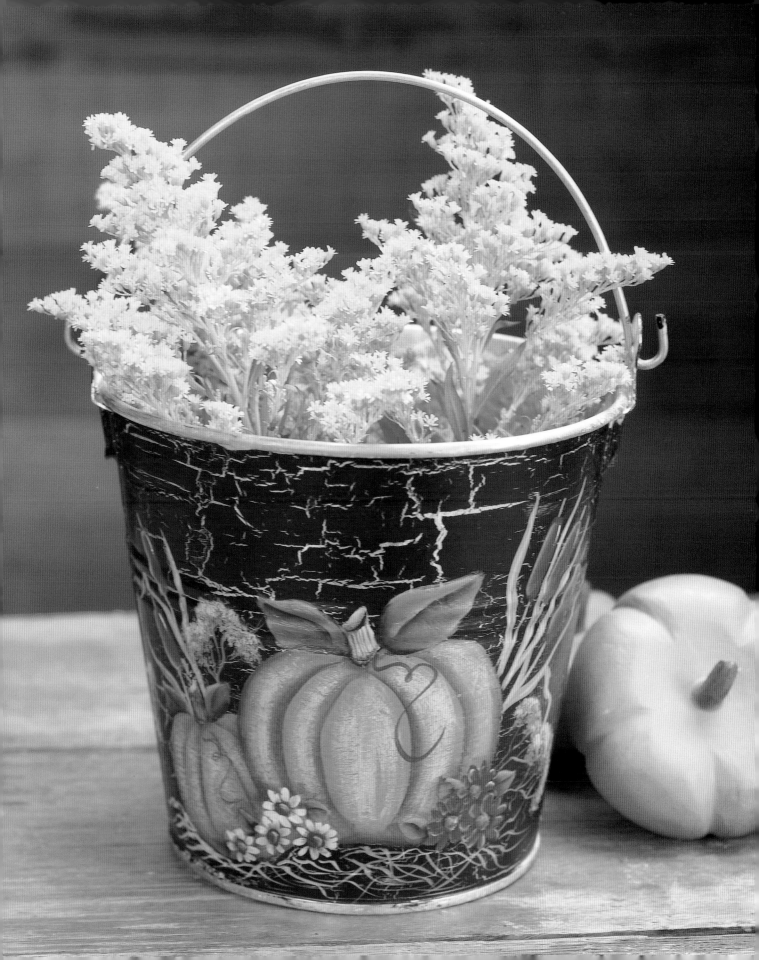

Harvest Pattern

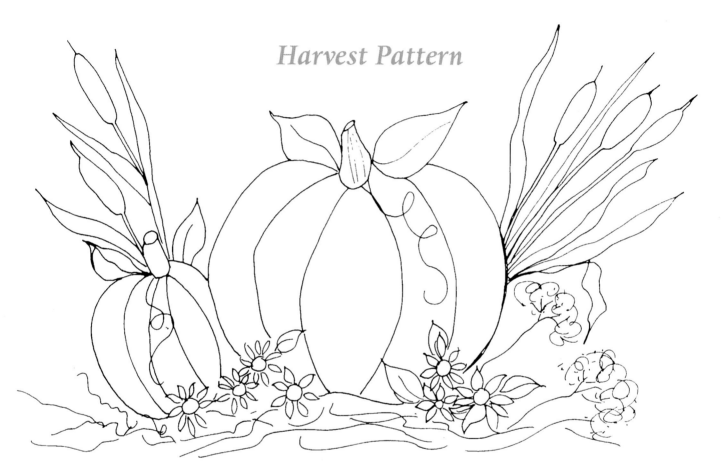

Pattern is actual size.

3. Using double-loaded #6 flat, paint leaves with Burnt Umber and Buttercup.

4. Using liner, paint stems with same color mixtures.

Sunflowers:
1. Load #2 round with Buttercup and mix well into bristles. Paint left flower cluster petals.

2. Load #2 round with True Burgundy. Paint petals of right flower cluster. Let dry.

3. Using angular, add highlights with blending gel plus Warm White. Lightly touch each petal.

4. Paint centers with Burnt Sienna. Let dry.

5. Using stippler, stipple centers with Buttercup.

Yellow Wildflowers:
1. Blot wildflowers with Buttercup.

2. Load stippler with Burnt Sienna, blot, and lightly tap on top of Buttercup.

3. Using liner, paint stems with inky Maple Syrup.

Straw:
1. Paint straw with an inky mixture of Buttercup plus Warm White plus Country Twill. Let dry.

Finish:
1. Following manufacturer's instructions, apply several coats of sealer. Let dry.

Harvest Painting Worksheet

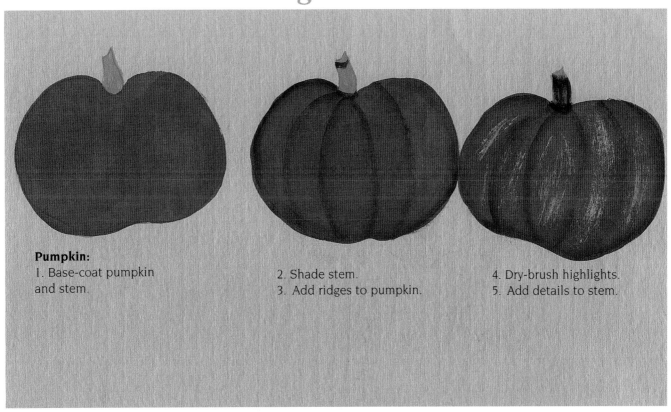

Pumpkin:
1. Base-coat pumpkin and stem.

2. Shade stem.
3. Add ridges to pumpkin.

4. Dry-brush highlights.
5. Add details to stem.

Rooster Bucket

Designed by Sandy Dye

Supplies

Project Surface:

Rusted-finish bucket,
 5½" dia. x 6" tall

Acrylic Colors:

Apple Spice
Inca Gold (metallic)
Maple Syrup
Medium Gray
Old Ivy
Orange Light
Red Light

Acrylic Pigment Colors:

Hauser Green Medium
Pure Black
Titanium White
Turner's Yellow
Warm White
Wicker White

Brushes:

Flats: #4, #10, ¾"
Liner: 10/0

Other Supplies:

Blending gel medium
Floating medium
Palette
Palette knife
Paper towels
Spray acrylic sealer

Stylus
Transfer paper
Transfer tools

Instructions

Prepare:

1. *Refer to Preparing Surfaces on pages 12–15.* Prepare bucket.

Paint the Design:

1. *Refer to Brushes to Use on pages 8–9.* Use appropriate brush type and size for area to be painted.

2. Base-paint bucket with Apple Spice.

3. Dry-brush with Pure Black, then Inca Gold.

4. Using finger, rub Inca Gold on rims. Let dry.

5. Following manufacturer's instructions, apply sealer. Let dry.

6. *Refer to Transferring Patterns on page 15.* Transfer Rooster Pattern on page 92 onto the bucket.

Rooster:

1. *Refer to Rooster Painting Worksheet on page 93.* Base-paint comb and wattle with Red Light plus Apple Spice.

2. Base-paint body and tail feathers with Pure Black.

3. Base-paint feathers, legs, and beak with Turner's Yellow.

4. Load #4 flat three-fourths full with floating medium. Tip corner with Hauser Green Medium. Blot. Stroke tail and body feathers.

5. Dip #10 flat in floating medium and pick up Orange Light on one corner. Blot. Highlight comb and wattle.

6. Mix a bit of Apple Spice plus Pure Black. Load brush with mixture plus floating medium. Shade comb and wattle.

7. Paint eye with Pure Black. Let dry.

8. Using stylus, dot eye with Titanium White.

9. Using liner, add lines on head feathers with inky Maple Syrup.

10. Using flat, shade legs with Maple Syrup. Blend. Using liner, add details with inky Maple Syrup.

11. Shade inside of beak with Maple Syrup.

Corn Bowl:

1. Paint lower portion of bowl with Medium Gray. Paint upper portion lightly with Turner's Yellow.

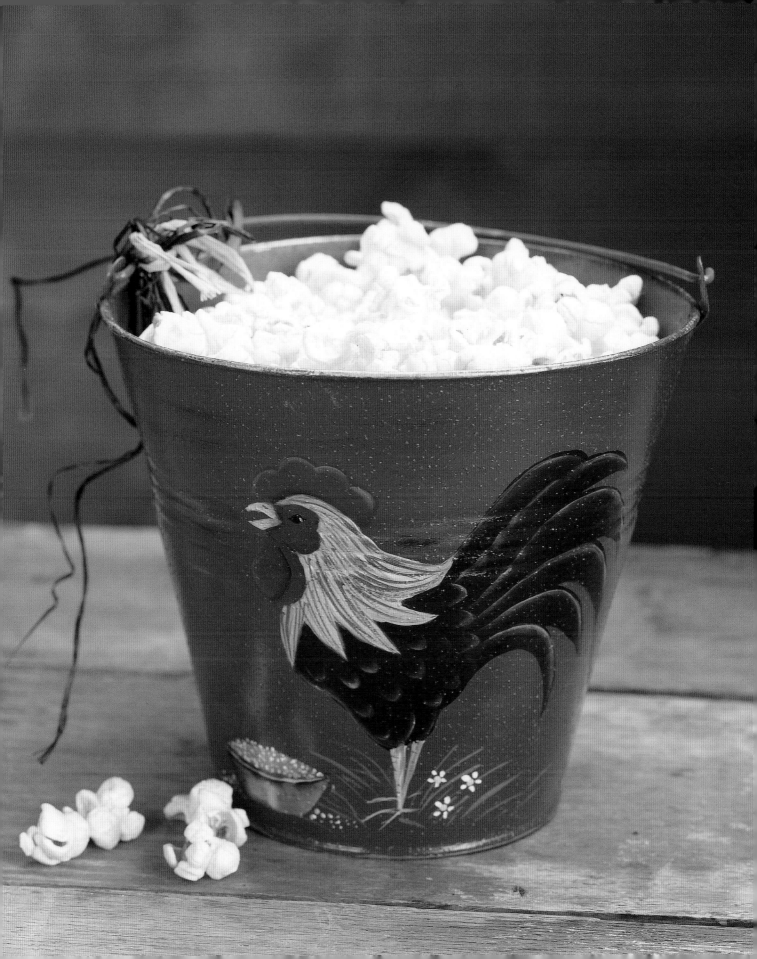

Rooster Pattern

2. Shade lower portion with Pure Black.

3. Highlight center and above rim with Warm White.

4. Using stylus, paint corn with Turner's Yellow and randomly with Wicker White. Add a little corn to the ground.

Grass & Flowers:
1. Using liner tip, paint grass with inky Old Ivy.

2. Using stylus, paint flower petals with Titanium White.

3. Dot flower centers with Turner's Yellow. Let dry.

Finish:

1. Following the manufacturer's instructions, apply several coats of sealer.

Pattern is actual size.

Rooster Painting Worksheet

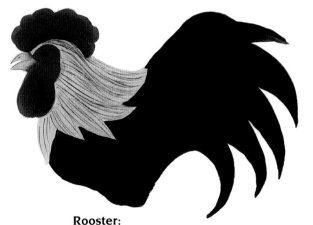

Rooster:
1. Detail head feathers.

2. Detail tail feathers.

Rooster Painting Worksheet

Comb:

1. Base-paint.

2. Shade.

3. Highlight.

Wattle:

1. Base-paint.

2. Shade.

3. Highlight.

4. Paint and highlight eye.

Beak:

1. Base-paint.

2. Shade.

3. Highlight.

4. Detail.

Legs:

1. Base-paint.

2. Shade.

3. Highlight.

4. Detail.

Corn Bowl:

1. Base-paint.

2. Shade.

3. Highlight.

4. Detail.

Daisies Sprinkling Can

Designed by
Sandy Dye

Supplies

Project Surface:
Flat-backed galvanized
watering can,
8" high x 2½" deep

Acrylic Colors:
Old Ivy
Pure Gold (metallic)

Acrylic Pigment Colors:
Burnt Sienna
Turner's Yellow
Warm White

Brushes:
Flat: #6
Round: #4

Other Supplies:
Floating medium
Palette
Palette knife
Paper towel
Spray acrylic sealer
Stylus
Transfer paper
Transfer tools

Instructions

Prepare:

1. *Refer to Preparing Surfaces on pages* 12–15. Prepare can.

2. Following manufacturer's instructions, apply sealer. Let dry.

3. *Refer to Transferring Patterns on page* 15. Transfer Daisies Pattern on page 96 onto can.

Paint the Design:

1. *Refer to Brushes to Use on pages* 8–9. Use appropriate brush type and size for area to be painted.

Daisies:

1. *Refer to Daisies Painting Worksheet on page* 97. Using round, paint petals with Warm White.

2. Place a small amount of Old Ivy on palette and add water to achieve an inky consistency. Paint stems and leaves.

3. Paint centers with Turner's Yellow.

4. Load flat with floating medium and wipe on paper towel. Dip a corner of brush in Warm White and highlight tops of centers.

5. Load flat with floating medium and dip one corner in Old Ivy. Shade petals around center on the open flowers and along petal edges for the buds.

6. Using same technique, float shading on centers with Burnt Sienna.

7. Float highlighting in centers with Warm White.

8. Using round, paint calyxes on daisy buds with Old Ivy.

Dot Flowers:

1. Using stylus, dot flowers with Turner's Yellow.

Finish:

1. Using finger, apply Pure Gold to handle and rim of can. Let dry.

2. Following manufacturer's instructions, apply several coats of sealer. Let dry.

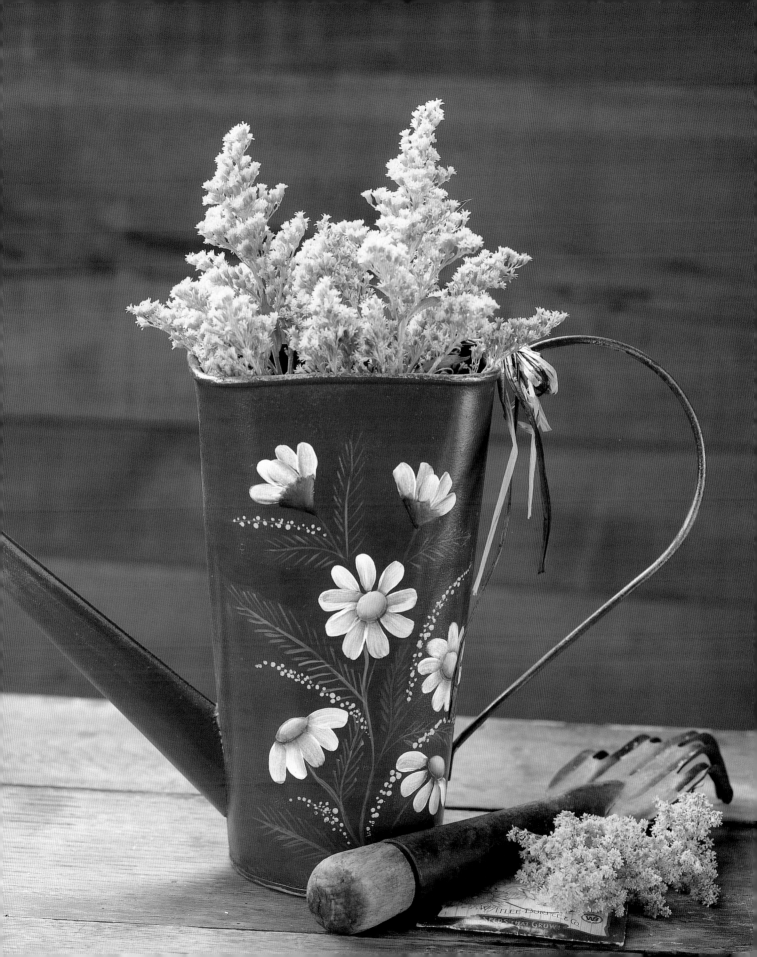

Daisies Pattern

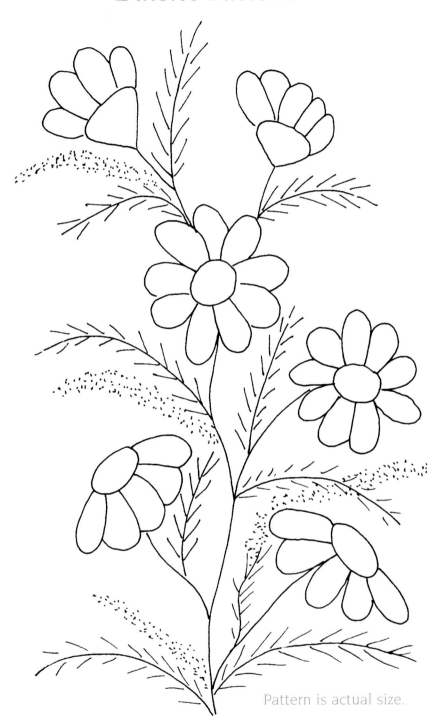

Pattern is actual size.

Daisies Painting Worksheet

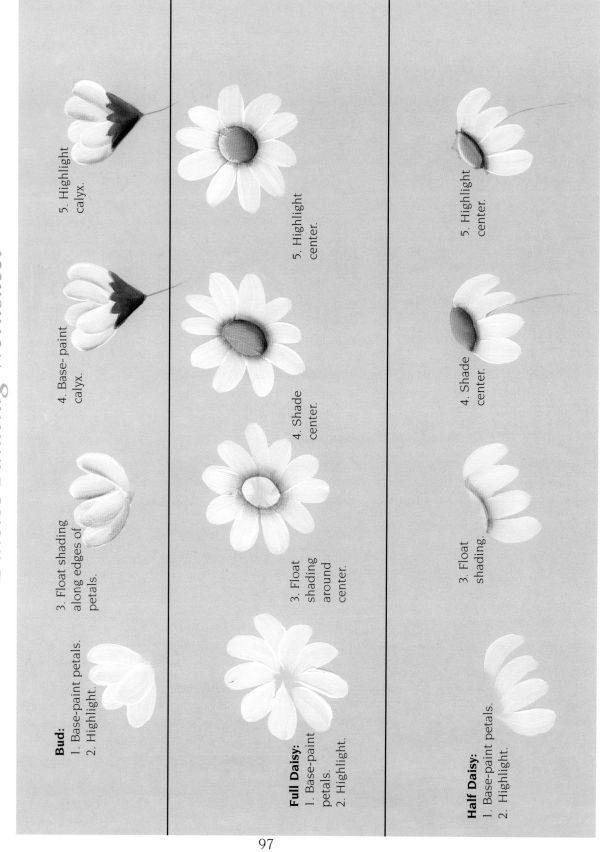

Bud:
1. Base-paint petals.
2. Highlight.

3. Float shading along edges of petals.

4. Base-paint calyx.

5. Highlight calyx.

Full Daisy:
1. Base-paint petals.
2. Highlight.

3. Float shading around center.

4. Shade center.

5. Highlight center.

Half Daisy:
1. Base-paint petals.
2. Highlight.

3. Float shading.

4. Shade center.

5. Highlight center.

Dots & Plaid Table

Designed by
Kathy Ward

Supplies

Project Surface:
Plastic resin side table

Plastic Paints:
Cobalt
Fuchsia
Light Pink
Light Yellow
Lime Green
Tangerine

Brushes:
Sponges: 1", 2"
Spouncer: ¾"

Other Supplies:
Black dual-tipped
 permanent marker
Craft knife
Low-tack masking tape, 2"
Palette
Plastic primer
Ruler
Sealer
Sponge block, 1" square
Stencil blank sheet

Instructions

Prepare:

1. *Refer to Preparing Surfaces on pages 12–15.* Prepare table.

2. Tape-off tabletop every 2" in area where plaid design is to be painted.

3. Make Cobalt glaze by mixing one-fourth bottle of Cobalt with three-fourths bottle of sealer.

Paint The Design:

1. *Refer to Brushes to Use on pages 8–9.* Use appropriate brush type and size for area to be painted.

Plaid:

1. *Refer to Plaid Painting Worksheet on page 100.* Paint uncovered area of stripes with Light Yellow. Remove tape. Let dry.

2. Load sponge with Cobalt glaze mixture. Going from top to bottom across tabletop, paint Cobalt stripes across the yellow stripes. Space stripes approximately 1" apart. Drag your pinky to steady your hand for a straight line. Let dry.

3. Using angled end of 2" sponge, cross through design with stripes of Lime Green. Cross both ways for a plaid effect. Let dry.

Edge Trim:

1. Following manufacturer's instructions, apply two coats primer to table edges. Let dry.

2. *Refer to Transferring Patterns on page 15.* Place stencil blank material over Dots & Plaid Pattern on page 100 for edging.

3. Using marker, trace pattern onto material. Using craft knife, cut stencil for this edging design, cutting along traced lines.

4. Tape stencil in place on one table side. Using 1" block, pounce Light Pink into cut out area of stencil.

5. With edge of 1" sponge, wisp in Tangerine accent on top of Light Pink. Let dry. Remove stencil.

6. Repeat on all sides of table.

7. Using spouncer, apply a dot at each point of the edging design with Fuchsia.

8. Using marker, outline edge of edging design. Wisp in tassel edge with same marker.

9. Using chiseled-edge of marker, drag for ¼" to create small square dots surrounding the edging design. Let dry.

Finish:

1. Following manufacturer's instructions, apply sealer to painted area. Let dry and cure before using outdoors.

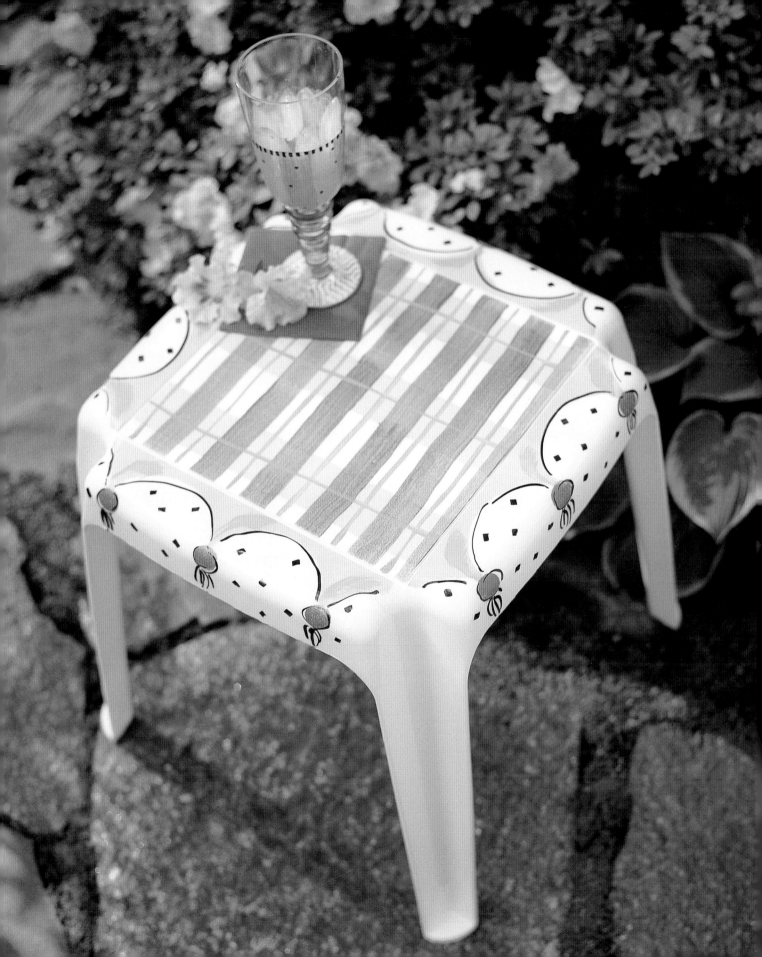

Plaid Painting Worksheet

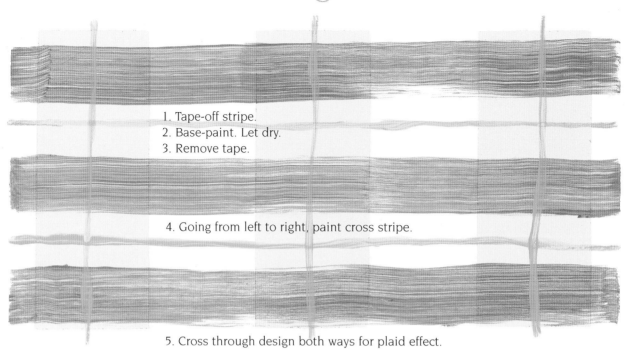

1. Tape-off stripe.
2. Base-paint. Let dry.
3. Remove tape.

4. Going from left to right, paint cross stripe.

5. Cross through design both ways for plaid effect.

Dots & Plaid Pattern

Enlarge pattern 200%.

Way to Grow
Planter

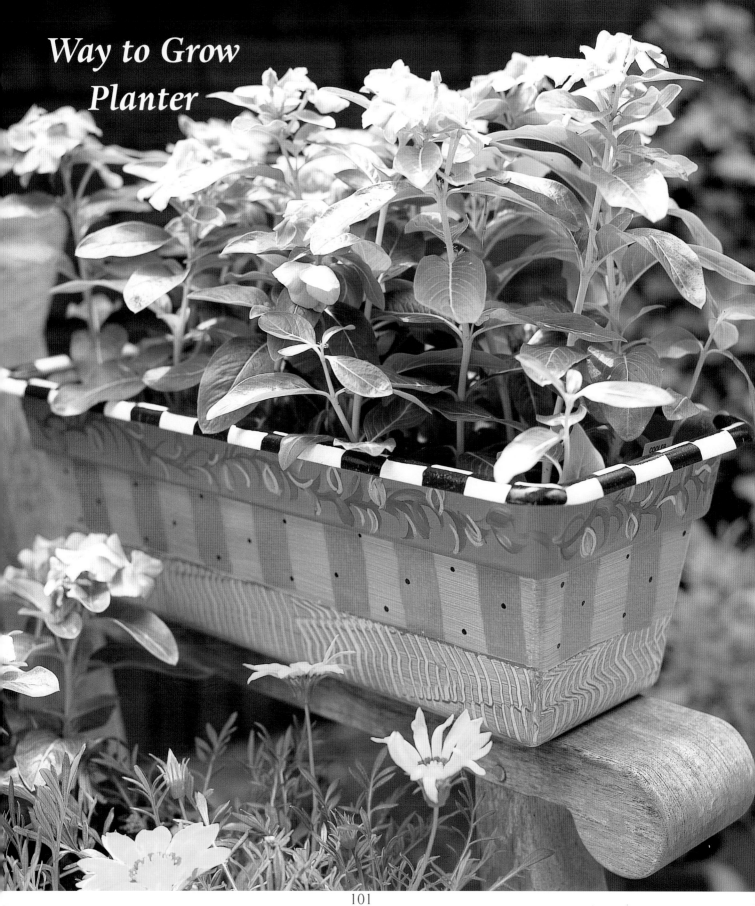

Way to Grow Planter

Pictured on page 101.

Designed by
Kathy Ward

Supplies

Project Surface:
Plastic planter box,
　terra-cotta color

Plastic Paints:
Black
Cobalt
Fuchsia
Green
Leaf Green
Lime Green
Metallic Gold
Tangerine
White

Brushes:
Flat: #6
Sponge: 1"
Sponge roller: 3"

Other Supplies:
Black permanent marker
Combing tool
Low-tack masking tape, 2"
Palette
Palette knife
Pen-tip set
Primer
Ruler
Water-based outdoor sealer

Instructions

Prepare:

1. *Refer to Preparing Surfaces on pages* 12–15. Prepare planter.

2. Coat entire outside of planter with primer. Let dry.

3. Leaving bottom 2" exposed, tape-off area above the bottom of box.

4. Using sponge roller, paint exposed area with White. Paint lip of box as well from just inside to outside of lip. You may need two coats of paint to cover opaquely. Let dry.

5. Make a Cobalt glaze by mixing one-fourth bottle of Cobalt and three-fourths bottle of sealer.

Paint the Design:

1. *Refer to Brushes to Use on pages* 8–9. Use appropriate brush type and size for area to be painted.

2. *Refer to Way to Grow Worksheet on page* 103. Paint white bottom of planter with Cobalt glaze. Using combing tool, immediately comb through design with downward curving motion.

3. Turn planter upside down. Using 1" sponge, paint stripes from blue combed area up to lip, about 2½" alternating with Fuchsia and Tangerine. Let dry.

4. Using marker, dot Fuchsia and Tangerine stripes.

5. Turn planter right side up. Using tip-pen, make wavy leafy vine with Leaf Green. Paint only a 5" section at a time.

6. Using flat, pull out leaves on both sides of vine. While wet, highlight with Green and Lime Green.

7. Highlight with Metallic Gold randomly along vine. Let dry.

8. Using 1" sponge, make checks at top white edge of planter with Black. Let dry.

Finish:

1. Following manufacturer's instructions, apply two coats of sealer. Let dry between coats.

Way to Grow Worksheet

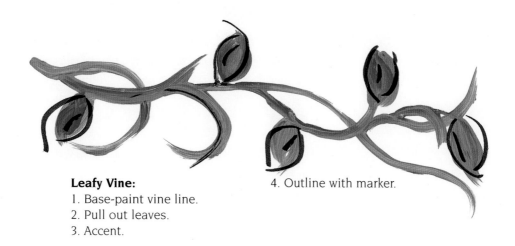

Leafy Vine:
1. Base-paint vine line.
2. Pull out leaves.
3. Accent.

4. Outline with marker.

Small Vine:
1. Base-paint vine line.

2. Pull out leaves along vine.
3. Accent.

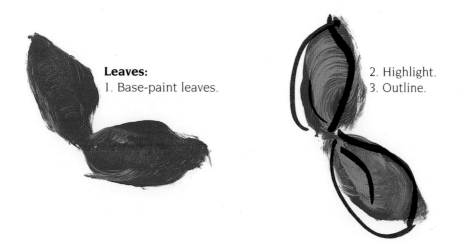

Leaves:
1. Base-paint leaves.

2. Highlight.
3. Outline.

Flower Table & Chairs

Designed by
Kathy Ward

Supplies

Project Surfaces:
Plastic resin table and
 two chairs

Plastic Paints:
Fuchsia
Green
Leaf Green
Light Blue
Yellow

Brushes:
Sponge roller: 3"
Sponges: 1", 2"
Spouncer, ¾"

Other Supplies:
Alcohol
Black permanent marker
Craft knife
Low-tack tape, 2"
Palette
Palette knife
Primer
Ruler
Sponge block, 1" square
Stencil blank sheets (2)
Transfer paper
Transfer tools
Water-based outdoor sealer

Instructions

Prepare:

1. *Refer to Preparing Surfaces on pages 12–15.* Prepare plastic table and chairs.

2. Following manufacturer's instructions, apply two coats primer to table and chairs. Let dry.

3. *Refer to Transferring Patterns on page 15.* Using craft knife, make flower and leaf stencil from Flower Patterns below.

4. Tape-off every 2".

Paint the Design:

1. *Refer to Brushes to Use on pages 8–9.* Use appropriate brush type and size for area to be painted.

2. *Refer to Flower Painting Worksheet on page 106.* Paint stripes on chairs and table with Light Blue. Let dry.

3. Using stencil and sponge block, paint flower with Yellow. Let dry.

4. Use spouncer, paint flower center with Fuchsia. Let dry.

5. Using stencil and sponge block, paint leaves with Green.

6. With 1" sponge, highlight leaves with Leaf Green. Let dry.

7. Using marker, dot table and chairs randomly. Outline flowers and leaves in a loose and free manner.

8. Using sponge block, paint checks at bottom of table and chairs, every other inch with Black.

Finish:

1. Following manufacturer's instructions, apply sealer to table and chairs. Let dry.

Flower Patterns

Enlarge patterns 200%.

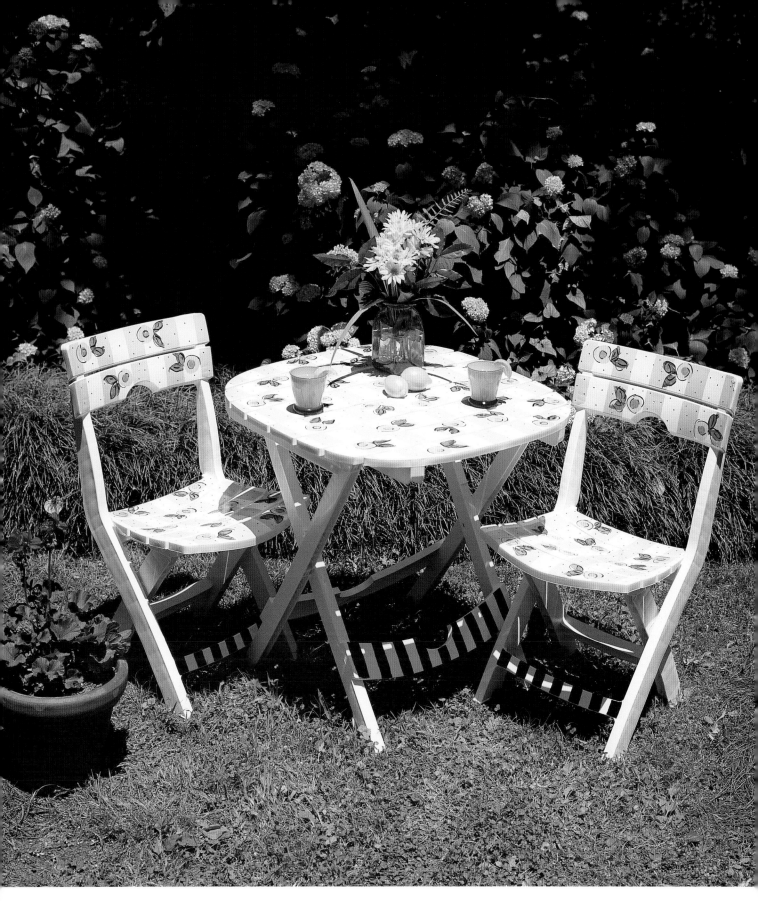

Flower Painting Worksheet

Round Flower:

1. Base-paint.

Rosebud:

1. Base-paint.

2. Create
 center dot.

2. Highlight.

3. Outline.

3. Outline.

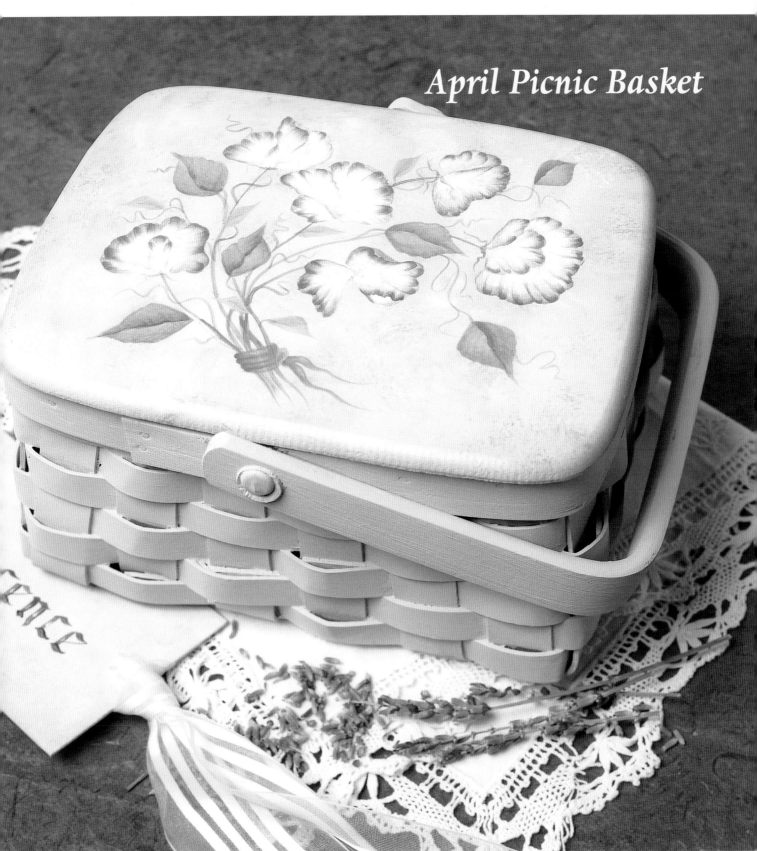

April Picnic Basket

Pictured on page 107.

Designed by
Di Singleton

Supplies

Project Surface:
Basket with wooden lid

Acrylic Colors:
Bayberry
Lavender
Light Gray
Light Periwinkle
Sunflower
Violet Pansy

Acrylic Pigment Colors:
Hauser Green Dark
Titanium White
Yellow Ochre

Brushes:
Flats: #6, #8
Liner: 10/0
Round: #5

Other Supplies:
Natural ocean sponges (2)
Palette
Palette knife
Sandpaper
Tack cloth
Transfer paper
Transfer tools
Water-based outdoor sealer

Instructions

Prepare:

1. Refer to Preparing Surfaces on pages 12–15. Prepare wooden basket and lid.

2. Apply thinned sealer. Let dry.

Paint the Design:

1. Refer to Brushes to Use on pages 8–9. Use appropriate brush type and size for area to be painted.

2. Base-paint with Light Gray. Let dry.

3. Work a little Lavender into damp sponge. Sponge lid to make soft tints. Soften by patting with a clean sponge. Repeat with Titanium White and Light Gray. Let dry.

4. Refer to Transferring Patterns on page 15. Transfer April Picnic Pattern below onto lid.

Leaves, Stems, Calyxes & Tendrils:

1. Refer to April Picnic Painting Worksheet on page 109. Mix Lavender plus Light Periwinkle (1:2). Add some mauve mixture to Bayberry for green mixture. Base-paint leaves.

April Picnic Pattern

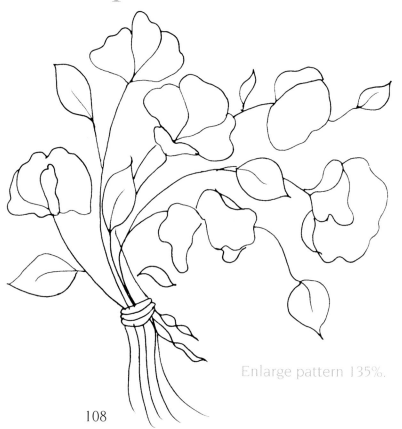

Enlarge pattern 135%.

April Picnic Painting Worksheet

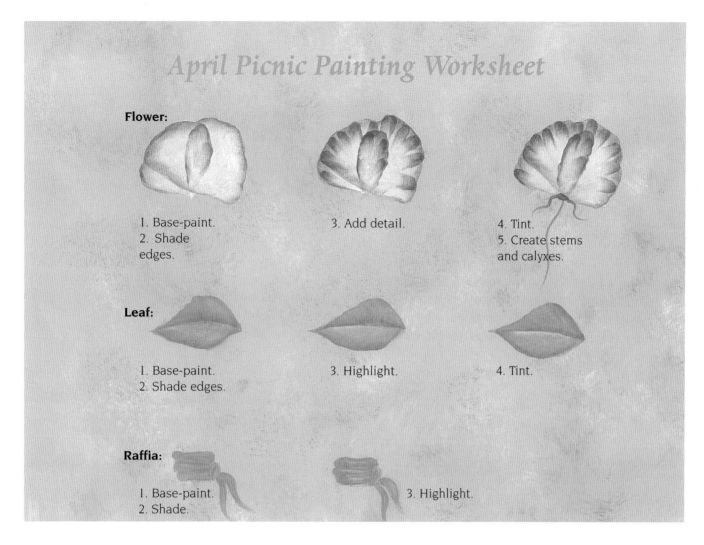

Flower:

1. Base-paint.
2. Shade edges.

3. Add detail.

4. Tint.
5. Create stems and calyxes.

Leaf:

1. Base-paint.
2. Shade edges.

3. Highlight.

4. Tint.

Raffia:

1. Base-paint.
2. Shade.

3. Highlight.

2. Add a touch of Hauser Green Dark to mixture. Shade down center and lower part of main leaves. Shade smaller leaves on center line.

3. Highlight center with Sunflower. Add random tints with mauve mixture.

4. Using liner, paint calyxes, stems, and tendrils with green mixture plus Hauser Green Dark.

Raffia:

1. Base-paint raffia with a touch of mauve mixture plus Yellow Ochre.

2. Deepen mixture with Hauser Green Dark. Shade between strands and down sides.

3. Using liner, highlight with Sunflower.

Flowers:

1. Base-paint with transparent Titanium White.
Paint edge on each petal with mauve mixture.

2. Add a touch of Violet Pansy to mauve mixture. Side-load flat and add frill details. Tint centers with Sunflower. Deepen tint with Yellow Ochre. Let dry.

Finish:

1. Following manufacturer's instructions, apply several coats of sealer.

Wrens & Hydrangeas Fountain

Designed by
Mary McCullah

Supplies

Project Surface:
Clay table fountain

Acrylic Colors:
Dark Plum
Gray Plum
Italian Sage
Night Sky
Solid Bronze (metallic)

Acrylic Pigment Colors:
Burnt Sienna
Burnt Umber
Ice Green Light
Pure Black
Titanium White
Turner's Yellow
Warm White

Brushes:
Filberts: #4, #2
Flats: #0, #6, #8, #12
Liners: 10/0, #2
Small dome
Sponge roller: 3"

Other Supplies:
Blending gel medium
Palette
Palette knife
Paper towels
Spray acrylic sealer

Instructions

Prepare:

1. *Refer to Preparing Surfaces on pages 12–15. Prepare fountain.*

2. Place Gray Plum and Ice Green Light on palette. Using sponge roller, create a soft unfocused background, rolling in all directions, alternating colors. Let dry. *Note: The Dark Plum and Solid Bronze trim on the fountain base are added after the design is painted.*

3. *Refer to Transferring Patterns on page 15. Transfer Wrens & Hydrangeas Patterns on page 113 onto fountain. Note: Be certain markings and feather lines on the right bird's wing and tail are darker than normal.*

Paint the Design:

1. *Refer to Brushes to Use on pages 8–9. Use appropriate brush type and size for area to be painted.*

Small Vase:
1. Paint outside with Gray Plum and the opening with Dark Plum.

2. Using #2 liner, paint trim around opening with Solid Bronze. Let dry.

Base:
1. Paint upper and lower rims of base with Dark Plum.

2. Using #2 liner, trim with Solid Bronze.

Birds:
1. *Refer to Wrens & Hydrangeas Painting Worksheet on page 115.* Using 10/0 liner, base-paint eyes with Pure Black.

2. Using #0 flat, base-paint beaks with Warm White plus a touch of Turner's Yellow and blending gel. While still moist, dry-wipe brush and shade tip with Burnt Umber plus Pure Black.

3. Using #4 filbert, base-paint heads with Burnt Sienna plus Turner's Yellow in light area and the rest in Burnt Sienna.

4. Using #0 flat, fill in light stripe over eyes with Ice Green Light.

5. Base-paint full bird's wing area and tail with Burnt Sienna plus Turner's Yellow plus a very small amount of Warm White. *Note: The pattern lines should show through the paint.*

6. Using dome, paint breasts with Ice Green Light and a little blending gel. Using a dirty brush, shade with Ice Green Light plus Dark Plum plus Turner's Yellow. The full bird also has some rust on the side of the breast near the wing—paint with Burnt Sienna plus Turner's Yellow.

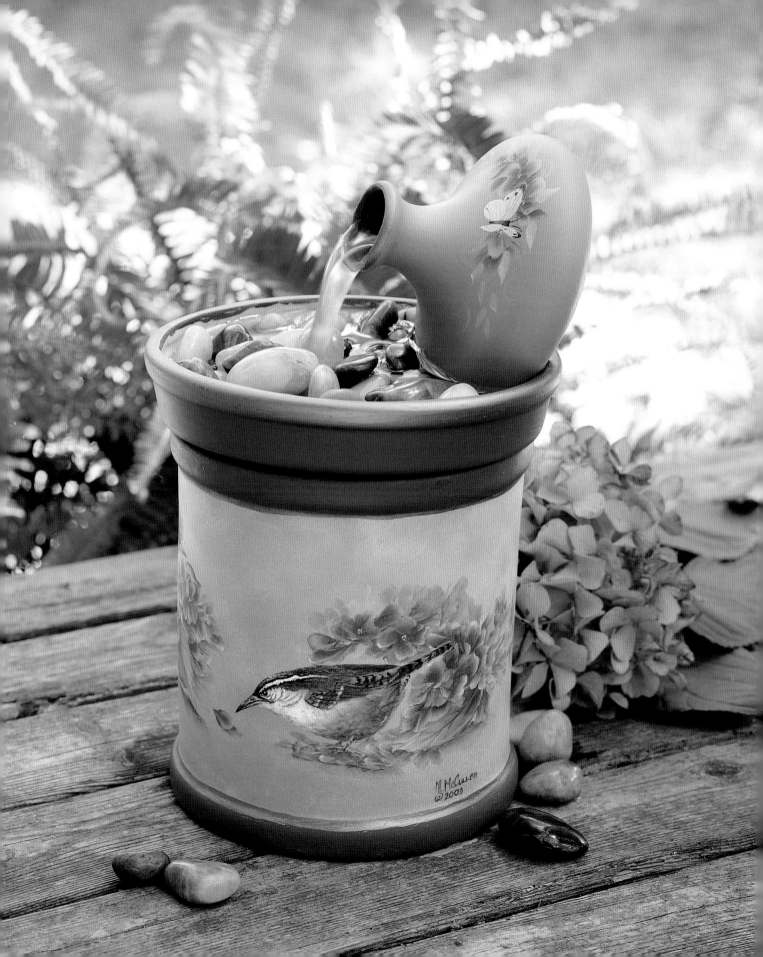

7. Using 10/0 liner, fill in feet with Ice Green Light plus Burnt Sienna.

Hydrangeas:
Note: *These flowers are very loose and soft.*
1. Using #4 filbert, scuff in Dark Plum and Dark Plum plus a touch of Night Sky and with some blending gel. Let dry.

2. Using flats, double-load with Dark Plum and Gray Plum, Dark Plum and Warm White for forward petals. Use Gray Plum plus Ice Green Light for distant petals. Stroke in each petal with light to outside edge and dark toward the center.

Main Leaves & Small Foliage:
1. Base-paint leaves and foliage with Italian Sage.

Hidden Bird:
1. Using 10/0 liner, feather head with short strokes of Burnt Sienna plus Turner's Yellow plus touch of Warm White, Burnt Sienna plus Burnt Umber, and Burnt Umber. Add a few strokes of Turner's Yellow plus Warm White in lightest area on top of head. Feather light stripe with Warm White and dark stripes above and below with Pure Black.

2. Paint a Warm White highlight and a broken line of Pure Black around eye.

3. Moisten beak with blending gel. Using #0 flat, strengthen dark area with Pure Black plus Night Sky, softening into lighter area.

4. Using 10/0 liner, pull a separation line between top and bottom of beak with same color.

5. Place hint of a nostril opening with a line of Pure Black plus Night Sky.

6. Feather breast with Warm White plus Dark Plum plus Turner's Yellow. Use different values of this mixture. In lightest area, stroke Warm White and add a touch of Titanium White for final light.

7. Paint markings on side of face and in neck area with Burnt Sienna plus Burnt Umber.

Full Bird:
Note: *Paint head, eye, beak, back, and breast areas in same manner as left wren, with these exceptions:*
1. Accent breast with Turner's Yellow plus Warm White plus Burnt Sienna under wing.

2. Using 10/0 liner, paint first two rows of wing feathers with Warm White. The rest of the markings on the wing and tail are Pure Black.

3. Separate feathers with a thin line of Burnt Umber plus Pure Black.

4. Shade feet with a touch of Burnt Umber plus Burnt Sienna. Add Burnt Umber lines on legs.

Hydrangeas:
Note: *Background petals are simply base-painted, while petals closer to the front are detailed. Be certain there are some loose, faint petals under bird's feet.*
1. Reset petals with the most contrast, using a flat double-loaded with Dark Plum and Warm White.

2. Paint softer petals with Dark Plum and Gray Plum.

3. Using liner tip, add some irregular dots with Turner's Yellow plus Warm White.

Leaves:
1. Moisten four large leaves with blending gel. Lay in a dark value with Italian Sage plus touch of Pure Black and Night Sky at back of each leaf and down vein line.

2. Side-load #6 flat with Italian Sage plus Turner's Yellow plus Warm White and pull in from the edge and soften into the dark paint.

Wrens & Hydrangeas Patterns

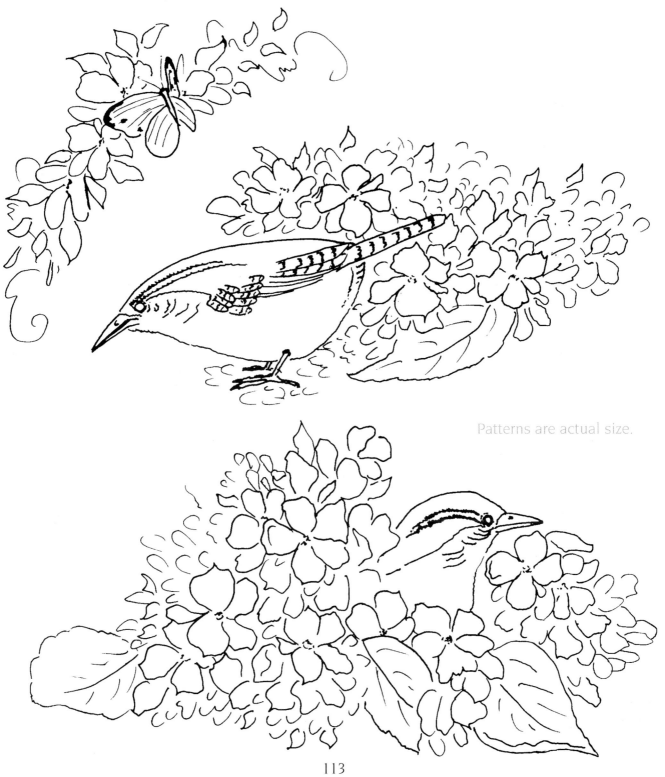

Patterns are actual size.

3. Using chiseled edge of brush, create vein lines with the dark mixture.

1. Using side-loaded #8 flat, glaze breasts of the birds with Burnt Umber plus Night Sky. Use this same color across back of hidden bird's head.

2. Glaze full bird to separate the wing from the back and the tail from the wing with Burnt Umber plus Night Sky.

3. Using #12 flat, glaze hydrangeas directly behind birds with Dark Plum plus Night Sky.

4. Shade leaves next to hydrangeas with dark green mixture.

5. Add shadows under leaf, hydrangeas, and bird with Burnt Umber plus Night Sky.

6. Using #0 flat, dry-brush highlights on breasts or petal edges with Titanium White.

Small Vase:

1. Using #6 flat, base-paint cabbage butterfly's wings with Ice Green Light. Add marking with Pure Black plus Night Sky.

2. Using #0 flat, paint body with Pure Black plus Night Sky. Tap Ice Green Light on top.

3. Paint hydrangeas, repeating steps from the major design.

4. Using a double-loaded flat, paint faint leaves with Italian Sage and Ice Green Light.

5. Using 10/0 liner, paint squiggles with Italian Sage.

Finish:

1. Following manufacturer's instructions, apply sealer. Let dry and cure for a week.

2. Assemble pump and fountain. Add stones and water.

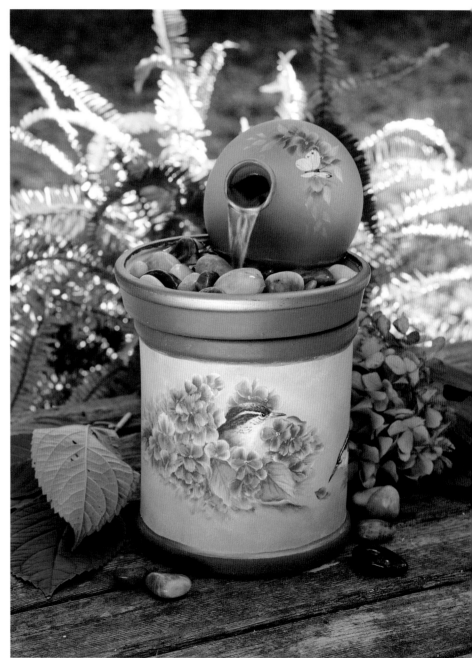

Wrens & Hydrangeas Painting Worksheet

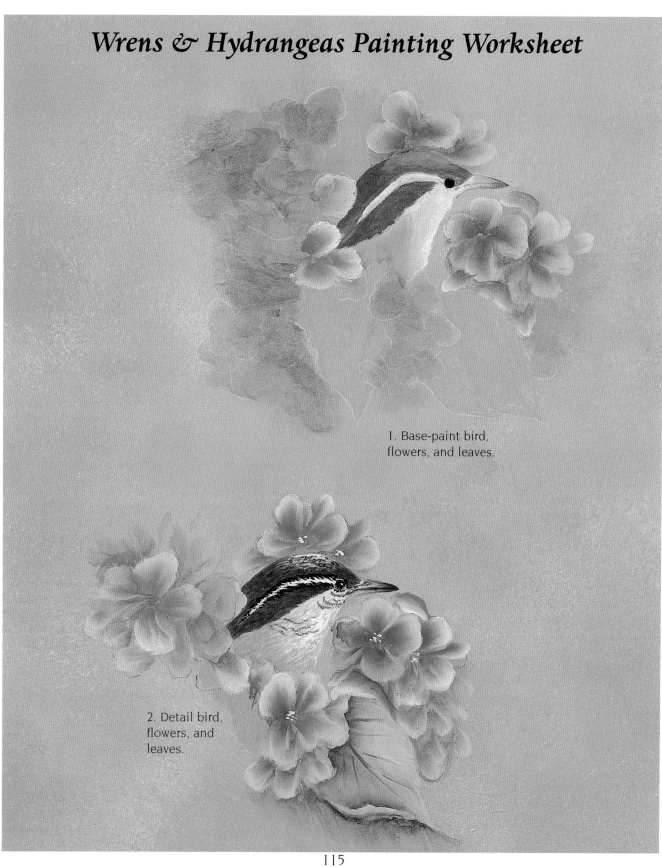

1. Base-paint bird, flowers, and leaves.

2. Detail bird, flowers, and leaves.

Garden Glow Sunflower Stool

Designed by
Mary McCullah

Supplies

Project Surface:
Twig stool, 14" square

Acrylic Colors:
Blue Ribbon
Italian Sage
Night Sky
Thicket

Acrylic Pigment Colors:
Burnt Sienna
Burnt Umber
Green Umber
Ice Green Light
Medium Yellow
Pure Black
Red Light
Warm White
Yellow Light

Brushes:
Filberts: #4, #8
Flats: #0, #12, ¾"
Liner: 10/0
Round: #4
Small dome
Sponge roller: 3"

Other Supplies:
Blending gel medium
Compass
Masking tape, ¾"
Palette
Palette knife
Paper towels
Ruler
Sandpaper
Scissors
Self-adhesive paper,
 12" square
Soft cloth
Spray acrylic sealer
Tack cloth
Transfer paper
Transfer tools

Instructions

Prepare:
1. *Refer to Preparing Surfaces on pages 12–15.* Prepare the wooden stool.

Paint the Design:
1. *Refer to Brushes to Use on pages 8–9.* Use appropriate brush type and size for area to be painted.

2. Using roller, base-paint top with Ice Green Light. Let dry.

3. Using ruler, locate center of top. Place a small amount of masking tape on sharp end of compass (to avoid leaving a hole in the wood) and mark an 8" circle in the center.

4. From center of the stool, measure and mark stripes in both directions, alternating ¾" and ¼" stripes.

5. Cut 8" circle from self-adhesive paper and cover center design area with it. Tape-off ¾" stripes.

6. Paint ¼" stripes with Italian Sage. Let dry.

7. Remove tape and self-adhesive paper. *Note: Place leftover self-adhesive paper on outside of design area to protect stripes while painting.*

Circle Background:
1. Using palette knife, prepare dark green mixture of Blue Ribbon plus Thicket plus a touch of Pure Black. Prepare a lighter mixture of Ice Green Light plus Blue Ribbon plus a touch of the dark green mixture.

Continued on page 119.

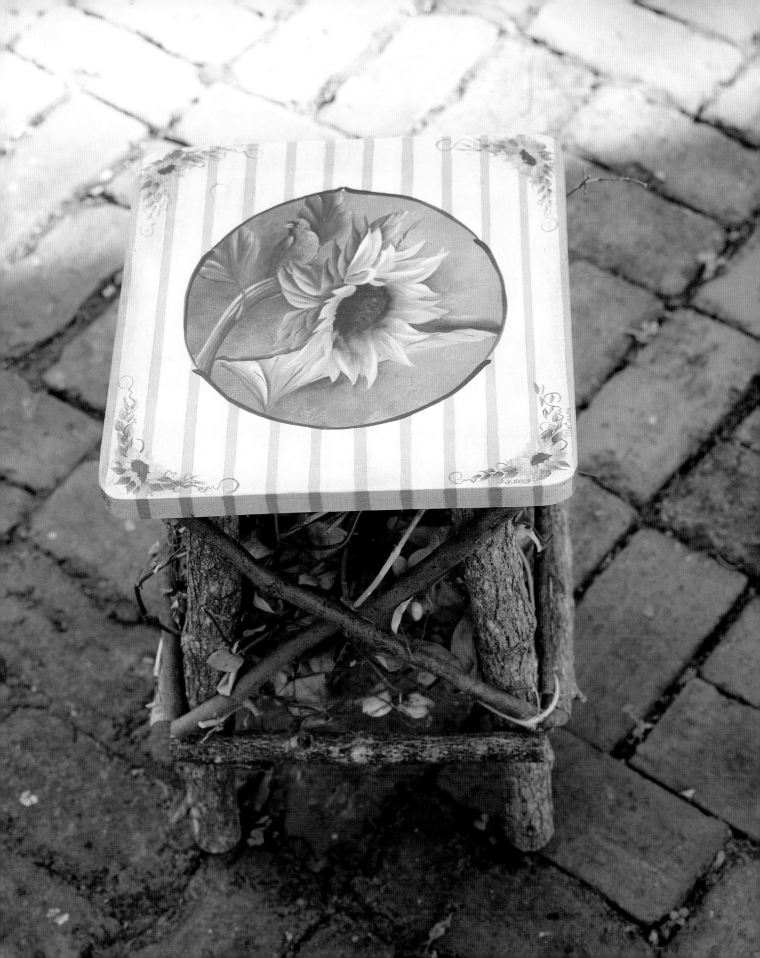

Continued from page 116.

2. Using roller, apply the two values, alternating without cleaning roller. Move roller in various directions to create a mottled background. Let dry.

3. *Refer to Transferring Patterns on page* 15. Transfer Garden Glow Sunflower Patterns on page 119 onto stool.

Bird:

1. Using #0 flat, paint beak with Ice Green Light plus a touch of Pure Black.

2. Using short overlapping strokes, base-paint head. To allow color to merge, pick up a small quantity of blending gel with paint. Use Blue Ribbon plus Night Sky in darkest area, and Blue Ribbon plus a touch of Warm White in lightest area.

3. Using same colors and technique, paint rest of bird. *Note: Right side of breast and right edge of upper wing are lighter.*

Sunflower:

1. Mix Medium Yellow plus a touch of Red Light to create a slightly orange yellow. Use this mixture for a darker value and Medium Yellow for a light value. Use a touch of blending gel to help pull petals from center out.

2. Use #8 filbert for the larger petals and #4 filbert for smaller petals. Starting on left side of center, fill in with short strokes of Burnt Umber working toward the right. About two-thirds of the way across, wipe brush and pick up Burnt Sienna to finish.

Leaves:

1. Create a mixture of Blue Ribbon plus Thicket plus a touch of Pure Black for a dark mixture. Pull some of this mixture aside and add Warm White plus Yellow Light for a light mixture. Also use Italian Sage as a light mixture.

2. The two leaves at top left of design are very dark. Use #12 flat double-loaded with the dark mix on the left and Italian Sage on the right, stroking in from the outside toward the center on the left side of the vein and then the right side.

3. The leaves that surround the sunflower have more of the mixture with Yellow Light. They are completed in the same way as the bigger leaves.

4. The smaller ones are stroked in with light on one side and dark on the other.

5. The large leaf under the sunflower takes a little more time. The top is the dark mix. Underneath is quite light with just a touch of the dark. Use a little blending gel to merge values. This leaf will be detailed later.

Stem:

1. Using double-loaded #0 flat, paint stem with the dark mixture and the light mixture plus Yellow Light. The light mixture is on the left side of the brush, the dark on the right. Starting on upper side, paint stripes across stem. Reload brush as necessary.

Bird:

1. Using 10/0 liner, add highlight at about 1 o'clock with Warm White. Add a broken line of Ice Green Light around eye to indicate rim.

2. Highlight top of beak with Ice Green Light plus a touch of Pure Black. Add a touch of Warm White on bottom edge of bottom part.

Garden Glow Sunflower Patterns

Enlarge patterns 125%.

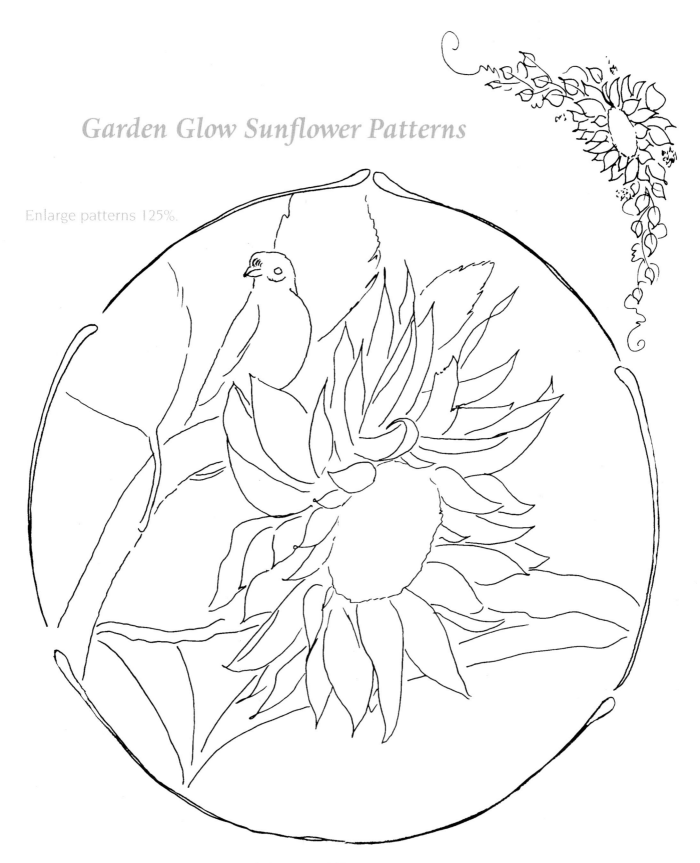

119

3. Create fine lines for feathers. Begin on head, move to breast, and finish with a few strokes on wing area. Stroke with Blue Ribbon plus Night Sky and Blue Ribbon plus Warm White. It may take several layers. Thin paint with blending gel plus a little water. Stroke dark area above beak and under beak with Pure Black.

Sunflower:

1. Using filberts, build up lights and darks on petals. For light values, use more Medium Yellow and Yellow Light. For darks, use Medium Yellow plus Light Red mixture and Medium Yellow plus Light Red plus a touch of Night Sky. The petals do not have to be perfectly blended.

2. Add Yellow Light plus Warm White in lightest areas.

3. Repeat the same process as the foundation layer to paint center with Burnt Umber plus Dark Night for the dark. Carry this over two-thirds of the way before picking up Burnt Sienna on the dirty brush. While this is moist, add some Medium Yellow plus Red Light on right third of the center.

Leaves:

Note: *Do as little as necessary to detail the leaves.*

1. If they need a little more dark or a touch of light, use a side-loaded #12 flat and pull in the color.

2. Add some blue accents on the leaves around the sunflower with Blue Ribbon plus Ice Green Light.

3. The large leaf at the bottom needs more work. Float Ice Green Light plus Blue Ribbon across the top of the dark edge.

4. Bring up any highlights needed in the bottom section with Medium Yellow plus Blue Ribbon plus Warm White.

5. Add some accents with the yellow-orange mixture.

6. Using 10/0 liner, add vein lines with dark green mixture. They are faint toward leaf tip.

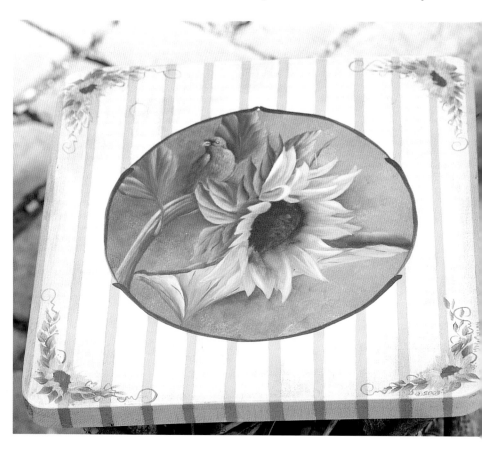

Stem:

1. Using side-loaded #0 small flat, reinforce darks and lights.

2. Attach upper-left leaves to stem with green values.

Glazing:

1. Using side-loaded #12 flat, glaze back of bird with Dark Night plus Pure Black to darken and sink him into the background. Using same mixture, glaze under head and around top of wing.

2. Glaze base of petals on right side of sunflower with Burnt Umber plus Dark Night.

3. Using side-loaded #12 flat, glaze right side of stem (the bottom) with Pure Black plus Thicket.

4. Using side-loaded #12 flat, add dark values under the sunflower, entire upper left, especially near bird, and under stem. Be certain blending gel is clean. Use dark mixture (Blue Ribbon plus Pure Black plus Thicket) in a slightly darker value.

5. Using filberts, dry-brush final highlights on petals with Warm White plus Yellow Light, and Warm White.

6. Using yellow and white mixtures, give a sharp highlight to stem curve.

Corner Trim:

1. Using dome, scrub in areas of Pure Black plus Thicket where design will be placed. Work with a touch of blending gel and bring some Italian Sage into the edges.

2. Using #4 filbert, establish a dark center with Burnt Umber plus Night Sky.

3. Pull in petals of Medium Yellow plus Red Light, Medium Yellow and Yellow Light. Note: *This is not the center of attention.*

Leaves:

1. Double-load #6 flat with a dark mixture of Thicket plus Medium Yellow plus touch of Pure Black on one side and Italian Sage on the other. Press down and lift, making a variety of sizes and colors of leaves.

2. Using 10/0 liner, paint the stems and curlicues with dark mixture.

3. Using stylus, dot flowers with Warm White, Blue Ribbon plus Night Sky.

4. Mix Thicket and Pure Black. Thin paint with a touch of water. Using #4 round, place comma strokes around circle.

5. Mix Dark Night plus Green Umber. Add blending gel to create an antiquing glaze. Using ¾" flat, apply to one corner of stool. Immediately soften with fingers or a soft cloth. Let dry.

Finish:

1. Following manufacturer's instructions, apply sealer. Let dry.

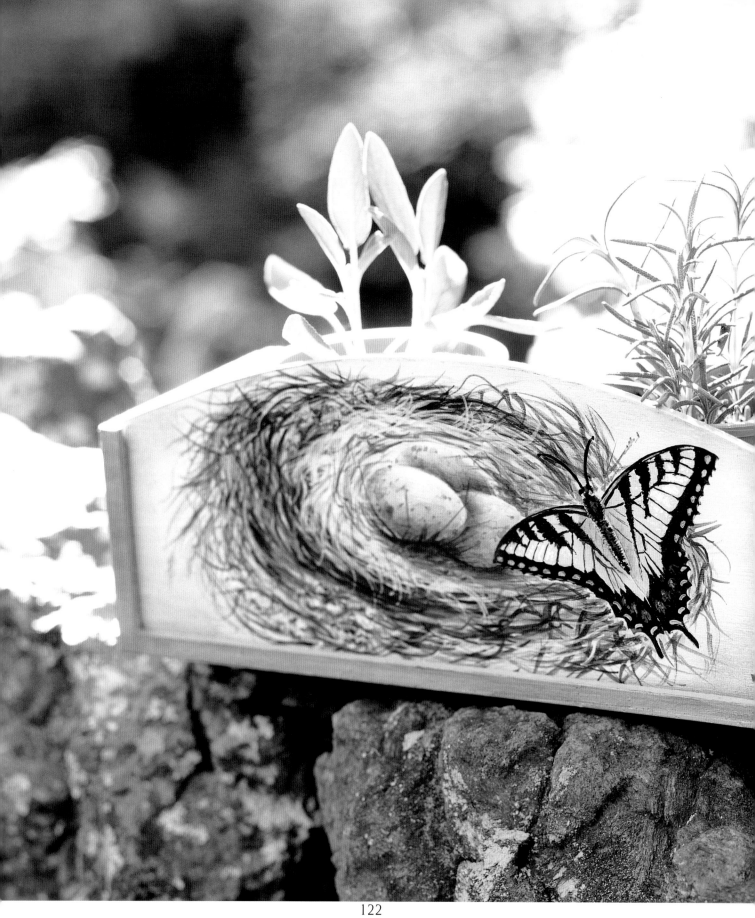

Babysitter Butterfly Planter

Designed by Mary McCullah

Supplies

Project Surface:
Wooden planter box

Acrylic Color:
Italian Sage

Acrylic Pigment Colors:
Burnt Umber
Green Umber
Ice Green Light
Medium Yellow
Prussian Blue
Pure Black
Raw Sienna
Warm White

Brushes:
Flats: #0, #10
Liners: 10/0, #1

Other Supplies:
Blending gel medium
Masking tape, ½"
Palette
Palette knife
Pencil
Ruler
Sandpaper
Soft cloth
Spray acrylic sealer
Tack cloth
Transfer paper
Transfer tools

Instructions

Prepare:
1. *Refer to Preparing Surfaces on pages 12–15.* Prepare wooden planter box.

Paint the Design:
1. *Refer to Brushes to Use on pages 8–9.* Use appropriate brush type and size for area to be painted. *Note: Use blending gel to work wet into wet.*

2. Base-paint side, back, and front with Ice Green Light.

3. Paint inside, bottom, and front edge with Italian Sage. Let dry.

4. Begin at either side and measure in ½", then mark ¼" stripes with a pencil. Tape-off ½" stripe to protect the paint.

5. Paint exposed ¼" stripe with Italian Sage. Let dry. Remove tape.

6. *Refer to Transferring Patterns on page 15.* Transfer Babysitter Butterfly Patterns on page 125 onto planter box.

Nest:

Note: When picking up colors, pick up enough blending gel so colors are slightly transparent.

1. Using #10 flat, slip-slap a base coat for the nest with Burnt Umber and Raw Sienna. Note: The outside will be darker than the inside.

Eggs:

1. Base-paint eggs with Ice Green Light plus a touch of Prussian Blue.

Butterfly:

1. Base-paint wings and body with Medium Yellow. At upper corner of wings, pick up some Warm White with the yellow. Let dry. If you cannot see pattern lines through paint, retrace.

Eggs:

1. Using side-loaded #10 flat, shade with Burnt Umber plus Prussian Blue plus Warm White. Highlight with Warm White. Let dry.

2. Thin Burnt Umber plus Prussian Blue with water to make a wash. Using the side of the 10/0 liner, make irregular splotches on eggs. Note: It works nicely to tap some with your finger.

Nest:

Note: The #1 liner works best for the majority of work; use 10/0 liner for very fine lines.

1. Establish nest with mixes listed below. Use water to thin paint to an inky consistency. The inside of the nest is much lighter with more yellow and brown tones. Color combinations are:
- Warm White plus Raw Sienna
- Raw Sienna
- Burnt Umber
- Ice Green Light plus Pure Black
- Warm White plus Burnt Umber plus Prussian Blue
- Burnt Umber plus Pure Black.

2. Using #0 flat, add lichen with two values. The shape of the lichen is random with lighter lichen in the front of the nest and darker on the upper left back. Color combinations are:
- Italian Sage plus Prussian Blue plus Pure Black
- Ice Green Light plus Prussian Blue plus Pure Black.

3. After stroking, add some Warm White plus Raw Sienna plus Medium Yellow inside the nest and hanging over dark front edge.

4. Pull some Burnt Umber nest strokes over eggs to help settle them in nest.

Butterfly:

Note: If you cannot see the detail pattern lines, retrace them.

1. Using #0 flat and 10/0 liner, add markings with Pure Black on wings. Wiggle brushes so edges are uneven. Let dry.

2. Using chiseled edge of #0 flat, seesaw in and out of yellow on body with Pure Black so edges are uneven.

3. Using 10/0 liner, add yellow markings on black edge of the wing.

4. Using 10/0 liner, add Prussian Blue plus Warm White markings on lower part of wing on the black edge.

5. Side-load #10 flat and float some Raw Sienna next to body on wing to darken.

6. Using tip of 10/0 liner, tap in some Warm White in upper yellow section of wings to catch more light.

7. Paint antennae with Pure Black.

8. Using side-loaded #10 flat, create shadow under eggs with Burnt Umber. Reset with Burnt Umber plus Prussian Blue.

9. Shade eggs with Burnt Umber plus Prussian Blue.

Finish:

1. Antique insert sides with Green Umber plus a touch of Burnt Umber and blending gel.

2. Using #10 flat, apply same mixture to sides of box. Place color at bottom and soften upward with your finger or a soft cloth. Let dry.

3. Following manufacturer's instructions, apply sealer. Let dry.

Babysitter Butterfly Pattern

Pattern is actual size.

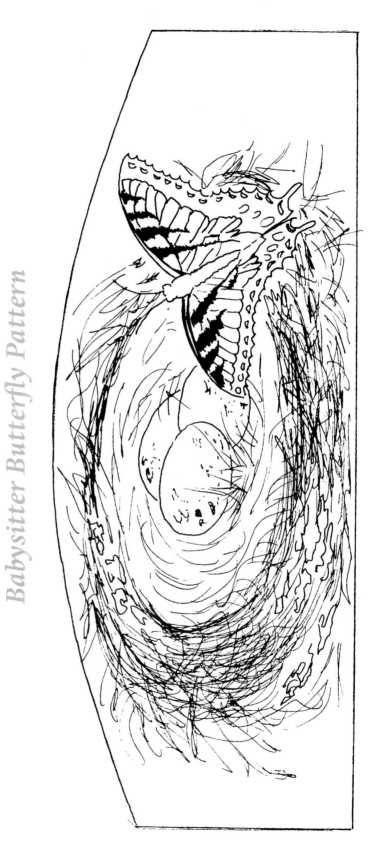

125

Metric Conversion

MM-Millimetres CM-Centimetres

INCHES TO MILLIMETRES AND CENTIMETRES

INCHES	MM	CM	INCHES	CM	INCHES	CM
⅛	3	0.3	9	22.9	30	76.2
¼	6	0.6	10	25.4	31	78.7
½	13	1.3	12	30.5	33	83.8
⅝	16	1.6	13	33.0	34	86.4
¾	19	1.9	14	35.6	35	88.9
⅞	22	2.2	15	38.1	36	91.4
1	25	2.5	16	40.6	37	94.0
1¼	32	3.2	17	43.2	38	96.5
1½	38	3.8	18	45.7	39	99.1
1¾	44	4.4	19	48.3	40	101.6
2	51	5.1	20	50.8	41	104.1
2½	64	6.4	21	53.3	42	106.7
3	76	7.6	22	55.9	43	109.2
3½	89	8.9	23	58.4	44	111.8
4	102	10.2	24	61.0	45	114.3
4½	114	11.4	25	63.5	46	116.8
5	127	12.7	26	66.0	47	119.4
6	152	15.2	27	68.6	48	121.9
7	178	17.8	28	71.1	49	124.5
8	203	20.3	29	73.7	50	127.0

YARDS TO METRES

YARDS	METRES	YARDS	METRES	YARDS	METRES	YARDS	METRES	YARDS	METRES
⅛	0.11	2⅛	1.94	4⅛	3.77	6⅛	5.60	8⅛	7.43
¼	0.23	2¼	2.06	4¼	3.89	6¼	5.72	8¼	7.54
⅜	0.34	2⅜	2.17	4⅜	4.00	6⅜	5.83	8⅜	7.66
½	0.46	2½	2.29	4½	4.11	6½	5.94	8½	7.77
⅝	0.57	2⅝	2.40	4⅝	4.23	6⅝	6.06	8⅝	7.89
¾	0.69	2¾	2.51	4¾	4.34	6¾	6.17	8¾	8.00
⅞	0.80	2⅞	2.63	4⅞	4.46	6⅞	6.29	8⅞	8.12
1	0.91	3	2.74	5	4.57	7	6.40	9	8.23
1⅛	1.03	3⅛	2.86	5⅛	4.69	7⅛	6.52	9⅛	8.34
1¼	1.14	3¼	2.97	5¼	4.80	7¼	6.63	9¼	8.46
1⅜	1.26	3⅜	3.09	5⅜	4.91	7⅜	6.74	9⅜	8.57
1½	1.37	3½	3.20	5½	5.03	7½	6.86	9½	8.69
1⅝	1.49	3⅝	3.31	5⅝	5.14	7⅝	6.97	9⅝	8.80
1¾	1.60	3¾	3.43	5¾	5.26	7¾	7.09	9¾	8.92
1⅞	1.71	3⅞	3.54	5⅞	5.37	7⅞	7.20	9⅞	9.03
2	1.83	4	3.66	6	5.49	8	7.32	10	9.14

Paint Conversion

FolkArt Acrylic Colors:

Apple Spice #951
Aspen Green #646
Autumn Leaves #920
Azure Blue #643
Barn Wood #936
Basil Green #645
Bayberry #922
Blue Bell #909
Blue Ribbon #719
Bright Baby Pink #223
Butter Pecan #939
Buttercrunch #737
Buttercup #905
Country Twill #602
Dark Plum #469
Engine Red #436
English Mustard #959
French Blue #639
Fuchsia #635
Glazed Carrots #741
Grass Green #644
Gray Green #475
Gray Plum #468
Honeycomb #942
Inca Gold (metallic) #676
Indigo #908
Italian Sage #467
Ivory White #427
Lavender #410
Lemon Custard #735
Lemonade #904
Licorice #938
Light Gray #424
Light Peony #517
Light Periwinkle #640
Lime Yellow #478
Linen #420
Maple Syrup #945
Medium Gray #425
Midnight #964

Navy Blue #403
Night Sky #443
Old Ivy #927
Orange Light #683
Parchment #450
Periwinkle #404
Poetry Green #619
Poppy Red #630
Pure Gold (metallic) #660
Purple Lilac #439
Raspberry Sherbet #966
Raspberry Wine #935
Red Light #629
Rose Chiffon #753
Rose Garden #754
Rose White #428
Settler's Blue #607
Sky Blue #465
Slate Blue #910
Solid Bronze (metallic) #663
Sunflower #801
Tangerine #627
Thicket #924
Thunder Blue #609
True Blue #401
Vintage White #515
Violet Pansy #440
Wicker White #901
Wrought Iron #925

Acrylic Pigment Colors:

Alizarin Crimson #758
Asphaltum #476
Brilliant Ultramarine #484
Burnt Carmine #686
Burnt Sienna #943
Burnt Umber #462
Christmas Red #958
Coastal Blue #713
Cobalt #720
Dioxazine Purple #463

Green Umber #471
Hauser Green Dark #461
Hauser Green Light #459
Hauser Green Medium #460
Ice Blue Dark #235
Ice Green Light #233
Medium Yellow #455
Napthol Crimson #435
Payne's Gray #477
Prussian Blue #486
Pure Black #479
Pure Orange #628
Raw Sienna #452
Red Light #629
Titanium White #480
True Burgundy #456
Turner's Yellow #679
Warm White #649
Yellow Citron #503
Yellow Light #918
Yellow Ochre #917

Plastic Paints:

Black
Cobalt
Fuchsia
Green
Leaf Green
Light Blue
Light Pink
Light Yellow
Lime Green
Metallic Gold
Tangerine
White
Yellow

Index